S0-BSI-481

09/24
STRAND PRICE
$ 5.00

Pop Wiener

5
6-

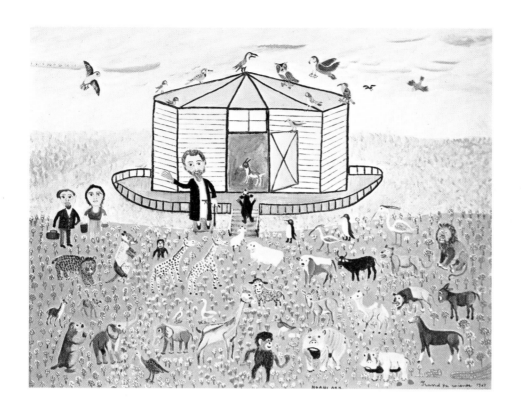

Frontispiece. *Noah's Ark*. Reproduced through courtesy of the New York State Historical Association.

PopWiener

Naive Painter

Joanne Bock

University of Massachusetts Press 1974

Copyright © 1974 by the
University of Massachusetts Press
All rights reserved

Library of Congress Catalog Card
Number 72–90499
Printed in the United States of America
Designed by Richard Hendel

Publication of this book has been financially assisted by
the Dixon Ryan Fox Fund, New York State Historical
Association; three anonymous donors; the New York State
Historical Association; the Adas Israel Congregation;
Mr. and Mrs. Alexander Hassan; Mr. and Mrs. Samuel
Weiner; B'nai B'rith, Washington, D.C.; Mr. Bradley
Smith; the David Lloyd Kreeger Foundation; the
American Council of Learned Societies under a grant
from the Andrew W. Mellon Foundation.

Photographs from the New York State Historical
Association, unless otherwise credited, are by Matt Spiro.

For Ag and Lou

Contents

List of Illustrations

Preface

This is a study of the life and work of Pop Wiener, a naive painter, who began his life in Durleshty, Russia, in 1886, and who emigrated to the United States in 1901. I initially became aware of Isidor Wiener through Mrs. Louis C. Jones, wife of the former director of the New York State Historical Association, while I was a graduate student at the Cooperstown Museum Training Program in 1969. I became interested in writing my thesis about him, and made several trips to Monticello, New York, to interview the artist. The completed thesis has now developed into a much broader survey of Wiener's paintings.

Pop Wiener: Naive Painter emphasizes the relationship between the naive painter's life and work, demonstrating how each is dependent upon the other. It attempts to show how the joyfully colored, aesthetically pleasing paintings of a man who did not start painting until the age of sixty-five are infinitely more meaningful when the history of his life is told. It further points out that naive art is not "bad art" as it has sometimes been labeled but is a distinct type of art which must be considered artistically, as well as historically.

In accomplishing these ends I have in-evitably touched on the concept of the acculturation of the east European Jew into American society. Although I have not emphasized this idea in the book, the reader will perceive that it could be called a secondary theme.

There was a wealth of material to choose from to illustrate these points. Wiener was a prolific painter, creating over two hundred paintings. I have selected approximately forty of those paintings which appeared to have outstanding aesthetic and historical value from the collections of Mrs. Sandra Weiner in New York City, Mr. and Mrs. Samuel Weiner of Smallwood, New York, Mr. Jerry Cooke of New York City, Mrs. Judith Stanton of New York City, Mr. Bradley Smith of New York City and California, Mr. James O. Keene of Michigan and Mr. Robert Allen Aurthur of Amagansett, Long Island.

I found that the most appropriate way of documenting the work of the artist was through the field research methods of the taped interview and photographic documentation of paintings. My own European family background also was an immense aid in this endeavor as it enabled me to establish an immediate rapport with Pop Wiener.

Perhaps one of the most rewarding experiences I have had in the writing of this book has been receiving the cooperation of so many generous people who have contributed to it. I am especially grateful to Pop Wiener who gave so completely of himself and his time during the interviews and to Dr. Louis C. Jones and Mrs. Agnes Halsey Jones, directors of the thesis from which this book grew, for their advice, guidance and encouragement. In particular, I am grateful to Mrs. Jones for having brought Pop Wiener and his paintings to my attention as a possible research topic. I am also indebted to Dr. Sidney Kaplan for his sincere interest in my project and his suggestion that I send the manuscript to the University of Massachusetts Press.

I appreciate the cooperation and response of all the informants, especially Sandra Weiner, Pop's daughter-in-law, wife of his deceased son Dan, without whose assistance the research for this book could not have been accomplished. I am also grateful to Dr. Dan Grigorescu, Director of the Rumanian Library, New York City; Mr. Mircea Mitran, Cultural Attaché at the Rumanian Embassy in Washington, D.C.; Mr. Israil Bercovici of the Rumanian Jewish Theatre in Bucharest; Mr. Franz Josef Auerbach, also of the Rumanian Jewish Theatre in Bucharest; Mr. Marek Web of the Yivo Jewish Cultural Institute of New York City; Sister Justin McKiernan of the College of New Rochelle, New Rochelle, New York; Mr. Jerry Cooke and Mrs. Judith Stanton, who have purchased Wiener's paintings; Mrs. Sunna Rasch, an acquaintance of the artist during the time he lived in Monticello, New York; Mr. Daniel Doron, agent for the naive painter Shalom of Safed; and Mr. Morris Gertz, an informant from Washington, D.C., who had spent his early years in Bessarabia.

I am likewise grateful to the staff of the New York State Historical Association, Cooperstown, New York, especially Dr. Bruce R. Buckley, Mr. C. R. Jones, and Mrs. Doris Leslie, for technical assistance.

I am extremely grateful to Mr. Bradley Smith, who took all of the colored photographs for the book and many of the black and white ones. I also appreciate the photographic talents of David Blume. I thank Mr. Morris Welling, Mr. Robert Shosteck, Mrs. Dorothea P. Michelson, and Rabbi Joshua Haberman for their information and encouragement regarding the colored plates. Finally, I wish to thank my mother for her devoted typing of this work.

Pop Wiener

Introduction

"He painted as he lived—resolutely, vigorously, but with the delicacy of the physically strong,"[1] a noted authority on the subject of naive painting once said of the French artist Camille Bombois. It is a statement which applies equally well to the work of Isidor Wiener, a naive painter, Russian by birth, Jewish by religion, and American by adoption. Indeed, one can trace the most significant influences of Wiener's life, through the study of his paintings. His early years in eastern Europe, a rich religious heritage, life in the United States with its many vicissitudes, the joys of family, are all to be seen in a style which also reflects the spirit and optimism of a life which would not give in to adversity or difficulty. With strength of stroke and sensitivity of perception, Wiener created a pictorial history of those influences which shaped his life. The casual photograph could not have captured for him these personal images which Wiener made permanent with rich oils and the touch of his brush. They vividly portray the memories, feelings, and ideas of the Russian Jew who immigrated to America at the turn of the century, providing Americans with knowledge of the character and cultural background of a segment of their society. Wiener has made a unique contribution to the understanding of American cultural history, one which should not be forgotten—because he painted as he lived.

Pop Wiener, raised in the Russian shtetl of the late nineteenth century, was initially imbued with a sense of Jewish folklore. Grounded in the ethos of the Jewish people, Wiener was the recipient of a tradition which taught him to face life with realism and courage. Basic to this perspective was the Judaic belief in God's covenant with his people.

Through the study of the Torah and the folklore of the Midrash and Talmud, Wiener learned to value the fortitude and loyalty of the patriarchs and prophets who lived before him. In later years, the characteristics of his folk nature showed themselves in the intrepidity and optimism he exhibited in facing the paradoxes of daily life, and in the humorous but moralistic legends he would tell about his biblical paintings.

His Orthodox training was interrupted at an early age, when his parents were forced to move several times, bringing him into closer contact with the Rumanian culture. It was at this time that Wiener took the first steps toward his ultimate geographical and philosophical assimilation as an American Jew. The change and

3

influences brought about by economic, political, and family conditions broadened his outlook, preparing him to be receptive to cultural influences other than those of Judaism.

At this time another change was also taking place in Wiener's life. The long business trips his father made away from home and the death of his mother tended to make him extremely sensitive to the kindnesses the Rumanians extended to the persecuted Russian Jews. The beauty of the countryside likewise helped to fill the gap of loneliness which had been engendered by his circumstances.

Wiener became captivated by the color and grandeur of his natural surroundings and *Miorița*—a philosophy of harmony between man and nature which the Rumanian peasants cherished—became his own. Nature became his teacher and guide: he saw beauty in the trees, in the hills, in the constant reiteration of nature motifs that appeared in the tapestries the Rumanians hung on the walls of their huts, in their decorative carvings, and in the utensils they employed in their work.

Absorbing these new impressions and experiences, it became more difficult for Wiener to accept the strict orthodoxy of the Jewish religion. He began to look with admiration at the religious icons the peasants painted on glass, and with awe at the exteriors of the Moldavian monasteries, painted with biblical scenes. He delighted in the folk tales the Rumanians told: tales which gave a sense of identity to a boy who had been uprooted. Years later, he painted scenes filled with the motifs of the countryside and people who had been so dear to him.

The eruptions of the pogroms forced Wiener to leave this utopia. He set sail for the United States, where the acculturation process transformed him from an immigrant to an American Jew. A short while after landing in the new country Wiener settled into New York ghetto life. In spite of new obstacles he in general experienced a sense of well-being even as he strove to become an American. Many traits, such as his Yiddish accent, pragmatic manner of looking at life, and spirit of optimism in the face of suffering, remained with him, acquiring new dimensions in the transitional atmosphere of the East Side ghetto. His religious views, already liberated by life in Rumania, further expanded with exposure to American society. America became Wiener's home, friend, and joy, and nowhere was this more obvious than in the naive paintings he created a half century later.

Days of study in the *heder* and the majesty and mystery of the Rumanian countryside were not forgotten, however. The experiences of fifty years in the United States became amalgamated with the impressions of the old country, creating what can be called an American-Yiddish spirit in the artist's work. Wiener's use of motifs from the old country enhanced the American quality of his painting. His pictures show that a first-generation American is both proud of his native heritage and grateful to be in a country where he is able to share his background in security and peace. Wiener illustrated this American assimilation in his subjects, which express the euphoria of a man released from oppression who finds happiness in the small delights of life. Thus he painted pleasure-filled memories of free time spent with his family in a neighboring resort area, a portrait of John F. Kennedy, a Hudson River village.

The use of American themes was the first

indication that Wiener was beginning to be absorbed into the American naive painting tradition. Like the primitive painters who roamed the country in the late eighteenth and early nineteenth centuries, he used the available media as inspiration. Following in the wake of Edward Hicks, who found sources in copies of eighteenth-century prints, Wiener found his subjects in favorite television programs, magazines, and newspapers. At one point he went so far as to sign his paintings ''Grand Pa'' Wiener in order to imitate Grandma Moses. This is the reason many of his paintings are signed in this way, despite the fact that he was called ''Pop'' by his family and friends.

Frequently, Wiener's American spirit shows itself where least expected. When he created sculptured lions and birds which remind one of the animals in Jewish and Rumanian folk tales, he formed them from American hardware-store Plastic Wood. I have included a brief discussion of these animals in this book, in spite of its primary concern with Wiener's paintings, because they reveal the artist's talent with a variety of media.

This book, then, is the story of one man's innate ability to synthesize and utilize in a most creative way the myriad of experiences and stimuli which entered his life. I have not elaborated on, only mentioned, the influences which had a bearing on Pop Wiener's development because this study is intended to serve as an introduction to the body of paintings he created. In introducing Pop Wiener, I have sought to show that his paintings are aesthetically pleasing, historically significant, and distinctly American-Jewish.

One of the most important preliminary considerations of this book must be the problem of definition. There is perhaps no more difficult question to deal with when working with paintings created by artists such as Pop Wiener. The problem centers on the fact that several definitions have been used in reference to this type of painting and there has been little agreement among authors. These are but a few of the names which have been given to this art: primitive art, native painting, naive painting, art of the Sunday painter, art of the nonprofessional, folk art, instinctive art, nonacademic art, autodidactic art, naive-primitive art, etc.[2]

I do not intend to define the painting of Pop Wiener and others like him. Rather, I wish to explain why I have chosen the word *naive* from all the existing terms as appropriate for his work. The simple reason is that both Wiener's work and personality reveal this trait. In spite of a full and meaningful life, Pop retained a childlike way of looking at the world. There is nothing derogatory about the use of this word. Naiveté strengthened Pop and inevitably manifested itself in his painting. Sidney Janis has defined this quality:

Whatever the reasons may be, there are people in the world who always retain an untouched quality, a spiritual innocence regardless of their experiences in life. Somewhere within them is an impregnable quality carried over from childhood which experience does not assail. It is a spontaneous innate uncommon sense which remains inviolate in the face of outwardly imposed tensions and restraints. When these individuals paint, they rarely learn from a developed painting culture because it is far removed from their perception, and being removed, cannot touch them.[3]

It is remarkable that Pop, although separated from professional standards of painting, included in his paintings aesthetic devices typical of certain twentieth-century schools of trained artists. This is precisely where the naive quality becomes apparent in his work. As Janis says, the naive artist unconsciously flavors his work with the devices of the modern schools:

For instance, knowing nothing of Cubism, he may paint a picture in which a circulating viewpoint is used, or one that is counter posed like a Cubist painting. Knowing nothing of Surrealism, he may create enigmatic surface textures, use literary ideas and fantasies that are closely akin to Surrealism. Knowing nothing of Freud, he may undesignedly employ symbols similar to those Dali used with specific intent.[4]

Besides the quality of innocence, naive painting also exhibits many other characteristics. There is a forceful conviction, vigorous freshness, and native originality apparent in this art. Its colorful, decorative patterns are spontaneous and sincere. Its motifs, although often repetitive, display an intensity of feeling, a lively imagination, and a delight in discovery. There is frequently an instinctive joy, optimism, or sense of humor apparent in the subject matter chosen and the colors used. The lack of technical proficiency sometimes exhibited in this work, for example, an inability to paint perspective properly and a lack of proportion, enhances it, giving the paintings a homespun quality not apparent in the work of the academically trained.

The men and women who create this art are not bound to the traditions of a particular school. They are independent of them and express this freedom in their work. The lack of dependence on a school or style does not mean that these artists create works which are irrelevant to their times. Their work bears the stamp of the twentieth century. Janis reaffirms this idea:

[Naive painting] bears the stamp of its own times. Not only do fashions in clothes, furniture, decorations and the like, used in paintings reveal this, but attitudes of mind which inevitably come to these artists from the larger environments as well as from the commonplace experience of their daily lives.[5]

The following lines from Donald and Margaret Vogel are a very fine summary of the characteristics of naive painting. Although their statement pertains particularly to the life and work of the naive painter Aunt Clara Williamson of Texas, its content can be applied to naive painting in general. I therefore use this excerpt as a résumé of what I mean when I speak of the naive painter and naive painting:

For she is one of that especially gifted group of painters variously referred to as Primitive, Naive or Natural, to use the most common labels. She paints what she sees and remembers with simple innocence of vision and untutored hand. She seeks no aesthetic truths, belongs to no school, and understands little of art history or the paintings done by others. She paints because of a deep inner need to express what she feels; she creates spontaneously with little regard for public applause and with no knowledge of conventions and limitations of style. Decorative simplicity is in her paintings to be sure, but also the infinite delight in discovery and vividness of imagination that raise Mrs. Williamson's work from the quaint and charming to the stature of authentic art.[6]

6

To date two articles have been written on Pop Wiener. One appeared in the August 1970 issue of *Antiques* magazine, entitled "GrandPa Wiener, Painter of Many Worlds." The other appeared in the November 1971 issue of the *Connoisseur*, entitled "Grandpa Wiener: A Painter for Our Times." Both of these were written by the author of this book. Alfred Frankenstein, noted art critic, reviewed Wiener's work when it was exhibited in a one-man show in July 1970 at the New York State Historical Association in Cooperstown, New York. Frankenstein's review appeared in the July 12, 1970 issue of the *San Francisco Sunday Examiner and Chronicle* and was entitled "Cooperstown Discovered Grandpa."

Related works afforded some invaluable insights for the study. Sidney Janis, in his work *They Taught Themselves: American Primitive Painters of the 20th Century* treats the life and work of several notable naive painters. The inclusion in the book of excerpts from taped interviews, as well as the author's text, was of particular significance for my work on Pop Wiener.

Two works of Oto Bihalji-Merin, *Modern Primitives: Masters of Naive Painting* and *Primitive Artists of Yugoslavia* were excellent in stimulating ideas and avenues of study which were applicable to Wiener's paintings. The catalog entitled *Masters of Popular Painting: Modern Primitives of Europe and America*[7] was particularly helpful in obtaining an understanding of the definition of naive painting as well as its characteristics. A third work by Bihalji-Merin, *Masters of Naive Art: A History and Worldwide Survey*, shed much light on the distinctions between the many and various names given to naive painting. This was likewise true of Robert Goldwater's chapter on "Modern Primitives" in *Primitivism in Modern Art*. Both books provide a scholarly approach in the treatment of the naive painter.

Naive Painters of Czechoslovakia, by Arsen Pohribný and Štefan Tkáč, has introductory chapters which shed a great deal of light on such concepts as the relationship between naive painting and children's art.

Grandma Moses, My Life's History, edited by Otto Kallir, and *Aunt Clara: The Paintings of Clara McDonald Williamson*, by Donald and Margaret Vogel, are excellent examples of the type of study presently being done on the naive painter. The structure of those books was an aid in writing this one.

Several background books on Rumanian history were consulted for a better understanding of Pop Wiener's background. Denise Basdevant's work, *Against Tide and Tempest: The Story of Rumania*, afforded a concise, readable history which adequately summarizes the main developments of Rumanian history. The stories of Isaak Babel, *Benya Krik, the Gangster and Other Stories*, presented an excellent picture of what life was like for the young Jewish boy in Russia and Rumania during the time Isidor Wiener lived there. The play *Fiddler on the Roof*, by Joseph Stein, also provided background information necessary to the understanding of Jewish family life. Mark Zborowski's and Elizabeth Herzog's *Life Is with People*, however, was perhaps the most authentic view available of Jewish shtetl life in Russia in the late nineteenth century.

Books which dealt with Rumanian and Jewish folk culture and folk art were perused in order to discover whether

there was any indication of a specific folk tradition in the work of Pop Wiener. The most outstanding of these were the catalog published by the World's Fair Commission in 1940 entitled *Roumanian Peasant Art*, Nathan Ausubel's *The Book of Jewish Knowledge*, and *A Treasury of Jewish Folklore*. Haim Schwartzbaum's *Studies in Jewish Folklore* was indispensible in providing a bibliography on Jewish life and culture. Finally, James Yaffe's *The American Jews* and M. E. Ravage's *An American in the Making* were excellent sources of information on the acculturation of east European Jews in the United States.

2

'Pop' the Man

"He Sparkled, He Was Alive, He Was Vital." These were the words of a friend of mine who attempted to describe Isidor Wiener when she met him in Monticello, New York.[1] My own initial encounter in February of 1969 with eighty-three-year-old Pop, who had just recovered from a serious bout with illness, was much the same, although the vitality and sparkle were not immediately apparent. This was in part due to his illness and, I suspect, the atmosphere of shyness which naturally exists between the interviewer and the interviewee at the outset of their meeting.

What really impressed me about the small man with the abundant white hair was his air of dignity. It did not take me long to see and experience that I was dealing with an old-world gentlemen, as he offered me lunch, his slippers to warm my bootless feet, and insisted on carrying my tape recorder from room to room, treating me with the utmost courtesy and solicitude.

Pop's sense of humor and spirit of optimism gradually became obvious at this initial encounter. At first his humor was evident only in the smile which seemed to half emerge on his face when I began to react favorably to the two or three small paintings he had scattered around the modest two-room apartment. Later, as our shyness faded, it showed itself frequently in teasing and comments.

It was when Pop sat down to tell me his life story that the real spirit, vivacity, and energy of the man revealed themselves. These were the qualities which sustained him from his earliest days. For Pop Wiener, life meant to be alive, to sparkle, to be vital, come what may.

Early Days in Russia

Isidor Wiener was born in the Bessarabian village of Durleshty, one hundred and fifty miles from Kishinev in Russia, on January 1, 1886. He was one of five children, four sons and a daughter, born to Samuel and Jennie Wiener. Samuel Wiener was a Jewish businessman and landowner who produced grain and corn in large quantities. His work made it necessary for him to deal both with the Rumanian peasants and the Russian businessmen. He and his family spoke both Russian and Rumanian. "In the city we spoke Russian, in the country, with the peasants, we spoke

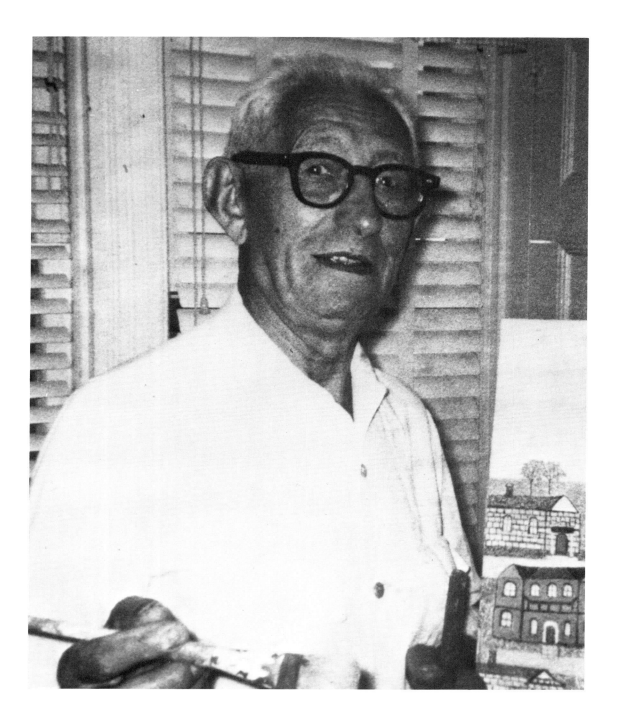

Figure 1. Pop Wiener, February 1969

Rumanian."[2] They also spoke Yiddish at home.[3] Despite his Russian birth, Pop shared Rumanian sympathies. When I questioned him about these leanings, he filled me in on the historical background of Bessarabia, as the Russian-ruled part of modern Rumania was called in the nineteenth century. He said:

When Russia had war with Turkey, years, years, years before I was born, Russia asked Rumania permission to go through to fight the Turks, because Odessa belonged to the Rumanian. So Rumania, damn fools, peasants, they peasants, let Russia go through to fight the Turks because Bessarabia was Turkish. So, they chased the Turks out but they said they saw the country is so rich and everything, so they remained there. Russia was powerful, big! Rumania was small, so was afraid. So they remained there and took away Bessarabia.[4]

Pop's memories of his earliest days roaming the Bessarabian countryside reveal that he was an impressionable child, who was sensitive to natural beauty, and especially to color.

I used to go in the woods, flowers, stuff like that. In the city of Kishinev we had a flower garden there, such a beautiful garden, that's all you could see is colors, colors, colors, everywhere you went.[5]

The productivity of this rich country was likewise an image which Isidor retained, no doubt because his taste buds, as well as his memory, were involved in the recollection. This was obvious years later when Pop spoke of the healthy land he once loved:

Healthy means the land was very fat. Every-thing that grows there has got a different taste. When I came to this country, the fruits there have a different taste altogether. The meat, I couldn't eat the meat here, it took me a long time to get used to this meat. The milk there is so sweet, just like you put in sugar. Not like this milk here, it tastes like water.[6]

The fruit there is so wonderful, so tasty. The fruits, the grapes, a different taste because the land is so rich. There's nothing in the world that doesn't grow there. They export all over the world from Bessarabia, where I come. Specially you ought to eat apples there, you'll see apples as big as this here.[7]

Isidor spent much time in those early days observing the Rumanian peasants who worked for his father. The making of wine, the plowing of the fields, the milking of cows, the daily activities of these people fascinated him. Relating how his father leased land to the peasants, he also revealed something of their life and his own pleasure in being able to witness to it:

We lived in the village, but the land was way out. They used to lease the land from the landowners. My father used to lease a lot of land. To plant wheat and corn you need a lot of acres. So we lived in a big village; it was way out of town. It was about two hours from the field where they used to work. In those days we used to have horse and wagon, oxen; horses used to plow the land. I used to go out, and on the fields there, was no houses. They used to, like the Indians, they used to dig holes and cover them up with straw, like the Indians, on the fields there. So, we used to go up there and stay there for days, we had a cow; we used to milk the cows there. We used to bring the stuff from the city to feed the people working there. I used to loaf around

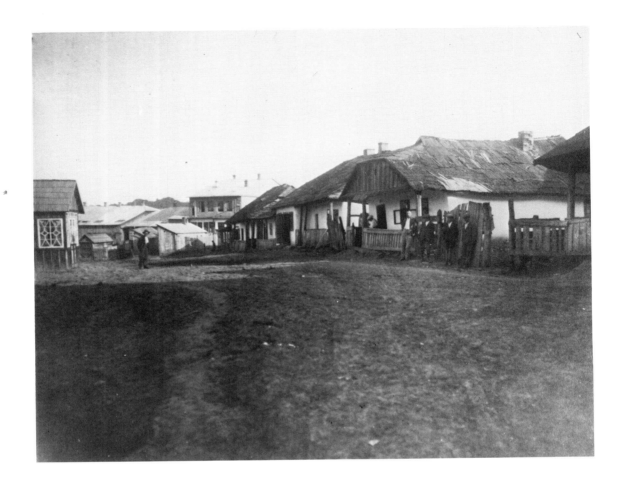

Figure 2. A typical Bessarabian village of the early twentieth century similar to Durleshty, where Wiener was born in 1886. Courtesy of YIVO Institute for Jewish Research, New York City.

there. We used to enjoy it. When you are young, you enjoy those things.[8]

The boyhood mischievousness which was still apparent in the old man was evident in Pop's description of the snakes he saw during these excursions to the fields. With great delight he said:

We used to have a lot of snakes there, a lot of cows, a lot of snakes over there. You could see these snakes, the dogs chased them, run in the grass; for miles you could see them.[9]

The young Jewish boy's entertainment was not limited to trips to the fields his father leased. Enjoyment and diversion could be found right in his own backyard; all that was needed was some ingenuity. Pop described the day he bartered a bag of apples for a small pup which brought him and his sister long hours of happiness, at the same time revealing his lifetime affection for all animals:

I love animals. When I was a kid I raised rabbits. I had dogs. Once hunters passed by our place. They were coming from hunting in the woods. In the back of our house we had an orchard with wonderful apples. One of the hunters said "Give us some of the apples." I said, "I'll give you a bag of apples if you give me one of the puppies." They had puppies since they were hunting. So I gave him a big bag of apples, a big, big, a sack of apples. Took them off the orchard and they gave me a pup. A young pup, it was a she. They went away, and I played around and had so much fun with that pup.[10]

It was likewise his love of animals which no doubt prompted Pop to remember watching the village children as they stood around the old milk cow with glasses to be

filled with fresh milk from her udder.

Life was not all fun and frolic. Although Pop did not refer to his educational experiences in a regretful manner, we may assume that the long hours spent in the Russian school during the day and the *heder*, or Hebrew Bible school, at night were often trying. Nevertheless, the impressions which the boy received from the colorful illustrations in the Russian textbooks and the lessons learned from the Hebrew Bible were lasting. He made a point of speaking of the influence the *heder* had on his paintings.

You know, when you are small you go to heder, you know, the Jewish school. You learn the Bible, you know, all about [it], and I remember that. Like I made Daniel and the Lions, I made Noah's Ark, it's from the Bible. I know the way according to the Bible tells you, that's the way I paint.[11]

Isidor learned to accept suffering early in life; his mother died when he was nine, and his little sister three, and he felt her loss keenly. The freckled beauty of his mother, who had been the counselor and doctor for the village peasants, seemed to be the memory which Pop retained above all others. "She was very beautiful," he said, "she had a face like my wife's."[12] After her death, Isidor was left to take care of his small sister.

I was nine years old when she passed away. I had two brothers, who were in the city in school. And my older brother and father had to be out in the fields in the summertime. I had a sister three years old, when my mother passed away. We couldn't get no servant there, we had to get a Jewish woman, she didn't want to stay in the village. My sister

always used to cry. I used to carry her, how small I was, I used to take care of my sister.

My father used to stay out in the fields, one o'clock, twelve o'clock, it took him time, on horseback he used to come down. He prepared for us in the morning, give us breakfast, prepare us lunch, and go away on the field, leave us home. All day long we used to play around; we had a garden in back of the house. Some other kids used to come, used to play around. I had to feed her. She used to always cry. In the morning my older brother used to pray, and she used to say, "Ma, Ma," like she used to see her. It used to scare us off, you know, like me, I was a small kid.[13]

He then went on to add that his father remarried a very kind woman. Before that happened, however, the family house was demolished by fire. It was a frightening event which the children faced alone. Wiener recalled how it suddenly happened one morning.

The hard luck we had, the first summer my mother passed away was before Easter. Around July, [my father] he's in the morning, he's making breakfast for us, he was baking egg plants with wood, used to use wood [to] cook soup. We had no coal, we had a stove for wood. We hollered, fire! fire! fire! We ran outside, our house got on fire. We didn't know how, and they didn't have no fire equipment. They had fire equipment they used to have on the truck, you had to put in water and with the pump, one guy stay on one side.

The pump, it didn't help nothing, the whole house went down. It didn't save nothing from the house. We had a lot of good stuff that my mother who passed away, afraid in case they break in, put on garret. Good linen, dishes, silverware. Everything gone. By the time they got through just the walls were left. In those

days there was no insurance, or nothing. We had to rent a place near the peasants until the house was built over. My brother kept pigeons on the garret. After we had that fire, they all come down and rest on the walls. They wouldn't go away from the place.[14]

The flames that destroyed the Wieners' home were far less detrimental, however, than the atrocities which were committed against the Jewish people in the Russian and Russian-controlled territories of the early twentieth century, for this was the age of the pogroms.

Pop remembered how initially the Jews were persecuted by the demands the czar placed upon them. There were only ten Jewish families in the village of Durleshty, but the czar gave an order that Jews must live over fifty miles from the city. This meant that Samuel Wiener had to leave a profitable business in Durleshty and move to the hamlet of Baican. Later, the situation in Kishinev became unbearable. The owner of a prosperous liquor store was forced to witness the raping and shooting of his teen-age daughter and wife. This was followed by the horrible hanging of a man on a huge hook in the local butcher store. These incidents made it clear to Isidor that Russia was no place for a Jew to remain in 1903.[15] He then set out to do something about it.

Journey to Freedom

Sandra, Wiener's daughter-in-law, has characterized Pop as a man full of independence, pride, and productivity.[16] Young Isidor showed his independence at the age of seventeen when he asked his older

brother, who had a banking business in Kishinev, if he could have the money to travel to America. His brother at first refused, saying, "Don't go, you'll never come back."[17] He next tried to persuade him to settle for a trip to Paris. Isidor was determined, however, and his reply was, "I'll run away if you don't let me go."[18] His brother was concerned for him, Pop later mentioned, not knowing what he would do for a living in the United States since he had never worked before. "They were afraid I would end up in jail,"[19] he laughed. Notwithstanding family protests, the boy got his way. His brother took him and six other young Jewish boys to the Austrian border, paying twenty-five dollars to smugglers who took them to Austria. They could not obtain legal passports because they were under age.

Pop's keen recollection of the actual smuggling sounds more like a fantastic adventure story than an event which actually took place. Many boys would have turned back after the first glimpse of the Slavic guides who escorted Isidor to the border, but he was not deterred. He described their appearance with his customary humor:

If you would look at those guys that took us over [the Austrian border]. They, Slavish, each one is so big they reach the ceiling. Guerrillas, you look at them and get afraid.[20]

He recalled with the authenticity of experience every detail of the dangerous trip.

They took us, with a wagon, two guys took us to, near a border. We had to lay down there in the grass there on the top of a hill till the patrol, there's a patrol there, the soldiers, they pass by. And near the border, there they

came to the tunnel, it's wide like for a few blocks, the tunnel, the water it goes.

So, there's a little shack there. We laid there on that hill till it got dark and when they know, they have eyes like cats, you never saw people like that, they look like really guerrillas.

It started getting dark, getting dark. They tell us. We took off the clothes, just shirt and the pants and the shoes. And the rest of the stuff they took away, and whatever we had they took away and told us to roll down the hill. Well, we roll down the hill, the hill was like this here a sandy hill. We couldn't walk, we had to roll down. We got on the end and zzzz zzzzz, you'll roll down until you come to the bottom, bango! You laid there dizzy because it was such a steep hill. And we all came down there and were laying like dead.

So, about six guys came up from that shack, they picked us up and carried us into that shack there. Boy! Opened our eyes, but you couldn't [see] from the sand, everything was covered. We, you know, we didn't think it was going to happen like that, that was the only way you could come down from that hill.[21]

The adventure did not end there. After the men put the youths in the shack they gave them the opportunity to clean up. At midnight, another surprise awaited them which, as Pop reflected, caused even him to be afraid.

After the patrol passed over again they told us to take off the clothes again. I thought for sure they were going to kill us. Six boys, young, we took the clothes off, shoes and everything and made a bundle and tied around the neck and 'Come on'—so they took us outside and we had to cross the water, the tunnel.

We started crossing, crossing, first you know it was low, low, low, and the water came

up to here, and the water was going so fast, I couldn't hold myself up, but those guerrillas are so big, one on one side, the other on the other side, was holding on to me, because the water could take me down. You know, it was going so fast, the water was up to here. So we got over the other side of the border in the woods.[22]

There Isidor and his friends went to a house where they dressed and ate. The next morning the six guides took the boys in a horse and wagon to a train. The train took them to Vienna. They next traveled to Rotterdam, where they stayed for a month before sailing for the United States. Pop's first memory of this city, reflecting his great interest in and love of animals, was of the huge, powerful horses he saw there.

They had horses there so big. They used to have big trucks, trucks. From the boats, trucks, they used to take 'um off. Big bails of merchandise. Load up the trucks, two [horses] used to pull them. A wagon like that over here you needed a big mack truck. I'm telling you had horses there you could lay on their back and sleep. Such big fat horses.[23]

A teen-age boy usually has interests besides animals, and seventeen-year-old Isidor was quick to notice the Dutch girls of Rotterdam. Years later Pop still retained their image:

There was a bridge, and it used to open up, in those days they opened the bridges where the boat used to go by; and we used to go out at six o'clock and watch hundreds of girls used to come over the bridges there, who worked in the factories.[24]

It was the kindness of the missionaries who had immigrated to Rotterdam, however, which really impressed the boy:

The people were so nice there. They had stores. Missioners used to be there because after the pogrom in Europe a lot of the people started to immigrate to U.S.A. and different countries. They used to have stores and they used to come in there and they had speakers and they used to try to convert us to their religion, Protestant, Catholic, or whatever, and they used to give us tea, cookies, cake, they used to help you out if you needed help. All the people used to, immigrants, used to go into these places and we didn't speak.[25]

He also recalled the displeasure of the Austrian Jews with him and his friends for associating with the missionaries who roamed the Rotterdam docks and reading the books they gave them. Pop's memory of the incident revealed that even in those early days his religious views were liberal: for young Wiener, religion was not so much a set of rules to follow, but a way of life:

And those Austrian Jews are so religious, they used to come out and they used to call us fonias, like pigs, because they know they want to convert us to a different religion and they used to be so mad on us. They used to give us books to read about their religion and we used to, and see what it is and read about it and those young boys used to run after us in the street and curse us, it was terrible. . . They hated us, just like the look of us, just like they hate the Spanish or Puerto Ricans. They used to call us svinja, it's a very dirty name in Russian, like pigs and stuff. . .[26]

After a month in Rotterdam the six boys set sail for the United States where they landed in New York City on June 28, 1903. At this point in my interview Pop commented, "It wasn't so easy to get here, was it?"[27]

Employment

Sandra Weiner's earliest impression of her father-in-law was that "he was always concerned about a man not earning a living."[28] This is understandable when one learns of the struggle Wiener had to support himself once he arrived in the United States. With determination, and a sense of humor, he worked at one job and then another. While he did not have the security of a prosperous business or the success of a lucrative trade, like his brothers whom he left behind in Kishinev, he did have the knowledge that his life was his own. No threat of a pogrom, extortion, or fear for his life plagued him. Thus, with a twinkle in his eyes he spoke of the varied kinds of work he undertook. For Isidor, these jobs were a way of making a new life; to others, they would have been drudgery. His first employment in the United States was making ruffles for dresses in a factory.

The first job, we went in, they used to be an office for immigrants. . . we went in and they. . . sent two of us to a factory, a German factory. They were making in those days dresses, ruffles, so they hired us, three dollars a week and they had a big box, a steam box, a metal box. You had to take the ruffles on bars. . . iron bars, and you had to work them up with your fingers. . . curl them and the steam used to come up and the ruffles you used to make with the steam, you had to pull 'em with your fingers. You worked there for about ten or fifteen minutes and all the skin came off your fingers, an awful pain.

So, I went and put on the steam a little less, I used to shut it off, and used to put it on full steam. So, we finished that week, and I said no more! "Quit—oh, he said, it will be all right,

you'll get used to it." He was a German, [it was] a German factory. So, I says, "Three dollars is not enough." So he said, "I'll give you four dollars a week."[29]

In spite of the fact that Wiener's pay was raised to six dollars, after two weeks of work he decided that his hands were more important than the salary. "I worked for two weeks," he said. "My fingers were all swollen up, but I had to work, and I couldn't stand it no more. I got calluses on my fingers, then, I quit."[30]

Wiener then worked in a hat factory. He also tried his hand at selling embroideries to tailors. One of his most amusing job experiences occurred the day he and another fellow attempted to dig graves in Brooklyn for soldiers who had died of malaria in 1903. One might assume that Wiener's association with the Rumanian farmhands in his native village would have made him quite capable of this work. He made it obvious to me, however, that he had never done any farming on his father's land. If he had not specifically revealed this, his reminiscence of the ditch-digging episode certainly would have done so,

We went to the cemetery; we worked there. We went in the morning, it must have been about ten o'clock, or ten-thirty—there was Italian fellows, big husky guys who were taking the stones out. So, I started digging, digging, digging. It came by eleven-thirty, gee, my back was broke, I'm not used to it.

Twelve o'clock, we took along some sardines, rolls, to eat, we stretched out on the grass, boy, we couldn't eat, my back was all broken. Afternoon we started working, we worked until six o'clock, he took us back to the office. So, we were gonna go home to New York to sleep. We tell the agent there "Well"

he said, "if you wanna sleep in the office, there's couches there." So, says, "let's go and sleep on the couch without pillows, without anything, soft couches."

Second day, the guy came down with horse and carriage; took us down to the cemetery. Well, we worked all week there. Every night we used to come back, go in and bring some groceries and eat in the office and sleep there. With the clothes, we couldn't take off the clothes, even. You know, you sleep there, just the jacket you took off. We got dirty, filthy there working, . . . we had to wash around he just give us a towel to wash around our hand and face.

We stayed there all week. The day before Rosh Hashana we came down to the city, then we looked at, you know, the clothes, digging, you know full of dirt, we looked like pigs. So, went into the house, changed our clothes; Second Avenue used to be a bath house, we went into hot, the Turkish bath, cleaned ourselves around, we went to the barber and shaved, you couldn't recognize us we looked like devils. After that we cleaned around everything, we got about nine dollars, nine dollars was a lot of money in those days; we had a week there. . . after that we forgot about farming.[31]

Wiener married while working as a hatter, his next position, and at this time he joined the hatters' union. He took the responsibility of supporting a wife seriously, so when the union went on strike, he sought employment elsewhere, but he found that it was more difficult to obtain work as a married man. Before becoming a milkman he had to earn the approval of his boss, who put him through tests and trials before accepting him as a permanent member of the staff.

I had a friend of mine who worked for a milk company, and he started very good, he started out with fourteen dollars a week, he had a good route near the Navy yard, he used to make a lot of commission. . . . So, I said, "Can you put in a good word for me?". . . His name was Max Muchnick.

So I went down there. . . they had a German inspector, they used to take only single fellows; they used to board in this place. A married man wouldn't stay with them. So [they] take young boys, didn't have no family and they used to . . . board with them. So, when I come there and they found out I'm married, it was no good. So what did [he] used to do, when he got a married man, they [he] used to send him out to break him in. [He] used to break him in for a week. He [the German inspector] used to chase him like dogs. [He] used to discourage him and they wouldn't come to work no more. So when he got me and this friend of mine told me the story, "He gonna kill you!"

It was in July, a hot day, it was a very hot summer. He said, "You know, he's gonna kill you. He'll send you up fifth floor with a pint of milk, fourth floor, third floor, he goes out late and then he start chasing you. You know, he killed one feller, he started working with him and he died. He got overheated and must have drank some cold milk and died from it. So, you be careful, because he's gonna kill you." So, I said, "All right, we'll see."

So, we started going out late and he started, third floor, fourth floor, and he sat on the wagon. You know, going from customer to customer, one customer here, you know, years ago someone took a pint of milk was a good customer. We used to sell milk for eight cents a quart those days. And he worked me, the first day was all knocked out. . . . I went home, laid down and I was dead. But I had to go again, got out the second day. I live in New

York and I had to go to Brooklyn to work. I went there for a week. Did he work [me] out for a week, I thought he was gonna kill me.

There's another thing, when you go on a route you have a horse, horse and wagon, those days. If you got a new customer here today, the horse goes off one customer, stops off next one. Then, from one customer, while you go upstairs, the horse moves over the wagon to the next customer. But he wanted to get me mixed up. He had early customers, he had late customers. So, he used to serve a couple of customers, they wanted milk earlier, run to one street, then to another, then to another street, he got me mixed up. When I got through, he let me off. I didn't know where to start because he used to jump around. So, I had a friend of mine the next route from me. He finished his route and come up and help me because he knowed I'll be in trouble. So this fellow showed me the right way; a friend of mine, because for the first couple of days I was all mixed up, I didn't know. . . .[32]

Later, he added, "I worked there for nine years."[33] It is surprising that the treatment he received did not break him, or at least force him to quit. This was not the case with Isidor Wiener, however, who saw, according to his daughter-in-law Sandra, that "each new day was another wonderful day to do your work."[34]

Pop's next job was selling rolls for a baker who had been on his milk route. He stated he did not like the job because "I had too much time on my hands, I used to come one o'clock back from the route."[35] Pop, as Sandra Weiner once mentioned, "had always exhibited boundless energy."[36]

When the bakery business began to decline, Wiener worked in an ammunition

Figure 3. Wiener as a cab driver, 1932–33

factory. He and his family moved to Waterbury, Connecticut, during World War I, while Pop worked at the Scoville Manufacturing Company. He also made his imprint on the car-wrecking business. In this work he was able to satisfy his desire to work with his hands as a mechanic, soldering and performing all those tasks necessary in this kind of labor. During the Great Depression, in 1932 and 1933, this business became unprofitable, forcing Pop to drive a cab in order to supplement his earnings.[37] Wiener and his wife later opened a small grocery and dairy store on 181st Street in the Bronx. He worked in this store until he retired in 1950 at the age of sixty-five.

Family Life

Life for Wiener was filled with hard work which allowed little time for leisure, but he managed to spend many happy hours with his young wife, Dora. Theirs was a very close relationship and a source of strength to Wiener. He met Dora Prlik in New York two years after his arrival in this country. She was born in Odessa, but her family came to the United States when the persecutions began in Russia.

Pop's description of how his marriage to this fifteen-year-old Russian-Jewish maid came about was characteristic. "I liked her," said he, "and I married her. I was afraid somebody else would grab her. Oh, she was a beauty."[38] Dora's beauty was not the sole reason for their happiness together. Pop said about his wife's disposition: "She was like an angel."[39] The years did not seem to weaken the close bonds between the couple. Years later Sandra noticed when dating the Wieners's son Danny, that Pop and his wife treated each other with a consideration and gentleness which married life had not diminished. She remembers also that Pop was always doing things around the house and that he would rarely let his wife do too much.[40]

Isidor and Dora moved in with Dora's parents, Mr. and Mrs. Prlik, after their marriage. They had three sons. Sam, their first child, was born in 1905 when Isidor was only nineteen. In 1913 Maxwell was born, followed by their beloved Danny in 1919. In 1917, little four-year-old Max was killed by an automobile while playing on the sidewalks in New York, In 1959, Danny, who had become a famous professional photographer, died in an airplane crash.

During the time Pop was struggling to make ends meet, Sammy, his eldest son, attended school, and then went on to learn the printing trade. Sam had some interesting recollections of Pop as he remembered him while growing up. He said about the talent his father exhibited around the house, "Pop was always very mechanical. He could do anything, plumbing, fixing cars, carpentry, any type of mechanical work."[41] When I asked him if Pop was very strict as a father, he replied, "My mother was much stricter than my father. . . . Pop was away most of the time working. My mother was very stern, when she issued an order, it was an order. We were brought up to obey."[42]

Dan attended high school, and while working on the class yearbook, developed a strong desire to become an artist. After finishing high school, he started to attend classes at Pratt Institute and the Art Students' League. At the same time he took odd jobs to help with the family income. Pop, however, highly disapproved of his son's artistic vocation. He felt that a man should have a trade so that he could support a family. Sandra Weiner spoke of a rift that developed between father and son over the question of Dan's career. "Pop wasn't very sympathetic . . . to any of the things Dan wanted to do," she said, "he just wanted him to be sure to learn something that would earn him a living."[43] Pop encouraged his son, however, when he later became interested in photography. He soldered trays for Dan to develop prints and helped the boy set up a darkroom.

Wiener's love of animals seemed to find an outlet in keeping cats while his family was growing up. Sandra recalled, "The family were great cat lovers, they had a lot

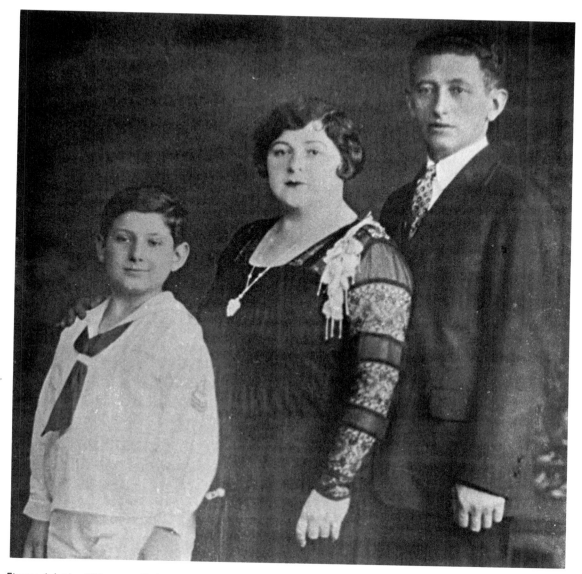

Figure 4. Isidor Wiener, wife Dora, son Danny, about 1929

of cats living with them almost all the time. Pop took very good care of them and nursed them back to health if they were sick, and anything like that."[44]

She likewise remembered how extremely capable, orderly, and neat Pop always was in the days she was dating Dan. These qualities were still apparent when I visited Pop in Monticello; he was able to manage himself and his apartment with great facility and efficiency.

21

Retirement and Painting

Dora's death in 1950 was one of the most difficult experiences in Pop's life. He and his wife had spent forty-six affectionate years together; now, for the first time since he had come to America in 1903, he had to go it alone. His expression still showed grief as he spoke of Dora's death in spite of the fact that it had taken place eighteen years before our talk.

His natural independence, productivity, and self-reliance once more asserted themselves, however. "I started painting,"[45] Pop said, a look of determination on his face. He relied on his own resources, decided that Dan's suggestion that he retire was reasonable, and then began to paint.

As Sandra put it, "Instead of feeling sorry for himself, he got seriously involved in painting."[46] Even after the tragic death of Danny, nine years later, Pop refused to become morose. His eldest son, Sammy, purchased a summer home in Smallwood, New York. In the summer months Pop took care of this home with meticulous care, planting flowers, painting, building patios and extra rooms. During the winter months, he spent his time painting in his apartment at Monticello and continued this pattern throughout his retirement until his death in 1970.

For Isidor Wiener, retirement, old age and even the death of close family did not produce decline but rather development and rejuvenation.[47]

22

3

'I saw it, I liked it, I painted it'

Beginning

It is somewhat difficult to comprehend how a sixty-five-year-old man who had never even held a paint brush or mixed oil colors, and whose only real experience in creative activities was the making of peach-pit animals and matchstick furniture, should suddenly start painting rich oil paintings, possessing pleasing aesthetic qualities, a delightful sense of vitality, and penetrating human warmth. Yet this seems to be the way of many naive painters. They have lived extremely active lives, concentrating on practical aspects, and it is only late in years that they have the opportunity to allow themselves to experience this enormous self-discovery. Oto Bihalji-Merin, who has written extensively on naive painting, does not find it unusual that so many of the naive painters do not begin to paint until late in life. He writes about the tardiness of their creative expression:

It is not surprising that some of the most important naive painters did not begin their artistic careers until they were well along in life; the later years bring the leisure necessary for productive activities. The Douanier Rousseau was not able to devote himself full time to painting until he had retired on a pension. The same was true of Vivin, the post office clerk, and of Hirschfield, who had been a manufacturer of boudoir slippers. Grandma Moses had to wait until the farm work had become too hard for her, to take up painting and find new meaning in life.[1]

This was likewise true of Isidor Wiener, who had spent his life eking out a living for his wife and three sons. There was a greater stimulus for Pop, however. Dan, his youngest son, realized how very lonely his father was after the death of his wife. Sandra Weiner recalls Dan saying to her, "He is so lonely, we ought to try and help him."[2] She remembered that this was about the time that Pop was eligible for retirement. Dan encouraged his father to retire and made sure he realized he did not have to worry about anything. He then bought his father a set of watercolors at the five-and-ten-cent store, and took him to their summer home in Amagansett, Long Island, where he began to paint. This was apparently what Pop needed to fill the vacuum. Painting enabled him to reach back over the years and recapture the beauty of the "old country"; painting filled the gap that Dora's death left in his life.

Even in this regard Pop Wiener did not set a precedent. As Arsen Pohribný and Štefan Tkáč explained:

It is interesting to note how many primitives lived away from their natural homeland; the Spaniard Vivancos in France; the Hungarian Garay, the Greek Karakevas, and the Russian Schmidtová in Czechoslovakia; Hirshfield, a Polish-Jew, in America. They looked to art to replace something they had lost.[3]

Technique

Pop Wiener soon made it clear that speaking of technique, like so many theoretical aspects of a naive painter's world, was unimportant to him. Initially, the only answer I received to my question regarding the manner in which he worked was, "Whatever comes into my mind, I paint."[4] The following quotation, taken from the work of Pohribný and Tkáč, is an excellent elaboration of Pop's simple answer.

The creative instinct of natural talent orders the images as they come, and these artists do not usually start with a clear idea of what they are going to paint. That is why their rendering is unique, even when they are varying the same motif.[5]

After rewording the question and observing the easel in the kitchen-studio at Monticello, I learned that Pop did not usually sketch his paintings on the canvas before he began to paint. He said, "I just paint."[6] On the other hand, when he painted buildings he sketched them first with pencil in order to get the exact proportions. For the most part he painted from memory, but occasionally used magazine pictures, photographs, etc., as sources. In reference to using a picture rather than a memory to paint from, he declared, "when you look at something, it comes much better."[7]

Pop had very definite preferences in the type of brushes he used. He described them in this manner:

Some people paint with big large brushes, I can . . . [only use for] a sky or big stuff. For small stuff, I buy by the dozens. I go down to the city, I buy brushes small, like number three, four, five, I buy 'em by the dozen. They cost fifty cents, sixty cents, a brush. I don't buy one or two. The modern painters, they take a big brush, go swish, swish, I can't paint that stuff.[8]

He also said that he did not use the palette knife instead of a brush as it made painting too easy. Wiener generally used Bocur and Grumbacher oils which he purchased at Macy's in New York City.[9] At one point he mentioned that he used to stretch his own canvases, but later on his daughter-in-law sent him linen canvases, which had already been stretched. He sprayed his paintings with a Damar Varnish Spray by Grumbacher, No. 545—a protective solution which prevents the colors from fading. He also used a Grumbacher linseed oil, No. 558.[10]

Pop would work on two or three paintings at a time. "I paint for a while, then I take a nap."[11] The nap in between times started after his 1969 illness. "I never had to do this before," he explained.[12] Wiener completed altogether over two hundred paintings. When I talked to him he was using only oil paints, although he originally began with watercolors. He recalled

24

that he made them too loose, and thus the colors ran. He used to throw away these early attempts.

Pop seems to have been a great deal more productive during the first few years of his painting career, which he spent at Amagansett, Long Island. He painted about fifty or sixty paintings during this time. "Now," he admitted when I talked with him, "I don't paint as much."[13]

Training

Wiener's only training was the guidance of his son Danny. When Danny first saw how well Pop was painting, he encouraged him to leave watercolors and paint in oils. Pop remembered him saying:

"Pop, you better start painting in oils and don't take no advice from nobody." He bought me all kinds of paints and brushes, I never knew how to use them. So, I asked him, he used to go to American Art School, he took painting himself. So, he said, "Pop, you have to learn yourself."[14]

Later Pop said he asked his son, "Maybe I should go to school?" His son's reply was, "No, they will kill you. If you go, you won't be able to paint."[15] In spite of this fact, Pop gave it a try. He related his brief and humorous attempt at attending Taft Art School in New York:

So, when I lived in New York after my wife passed away, I went to Taft Art School in the Bronx. I went there, I paid a dollar or two initiation, and I went there the first day and the guy was lecturing, instead of showing something, lecturing.

So I went another day, every time I come he kept on lecturing, and then he started showing us the painting. He took a model, a girl we should paint. I saw the way he was lecturing, the way he was explaining, he didn't know much about painting. So, I didn't go no more, I didn't bother. My son told me, "Don't go," he warned me not to go, so I didn't go.

I only went about two nights, two or three, yea. Then, the third night I had some paintings, small paints, I took them over to the school and I showed them to the teacher, so he said, "What are you doing here?," he chuckled and said, so I didn't go no more.[16]

Sandra remembers Dan helping Pop from time to time with colors, telling him for example to tone down his green. As always, however, Pop's most influential guidance came from his own hand. There is a very definite progression in his understanding of perspective, and facility in putting paint on the canvas. The detail of the posts in figure 5, from *Village Scene* (fig. 36), reveals that Pop originally painted telegraph poles and fence posts as a child would do. He felt each one as it went around the hill, as it would appear if he were in front of it. Thus, when the road curves, the posts lean over to match it. Later Pop improved in placing objects in proper perspective, as the fence on the hill (fig. 6) in *Two Cars Climbing a Hill* (fig. 77) clearly illustrates. This improvement bore witness to Pop's own statement that he kept getting better as he practiced painting. In *Housetops* (fig. 7), another early oil, Pop illustrates the kind of growth which must take place in any artist's work if he is to improve, advancing and regressing in the same painting. When he painted the roofs of the buildings on the right side of

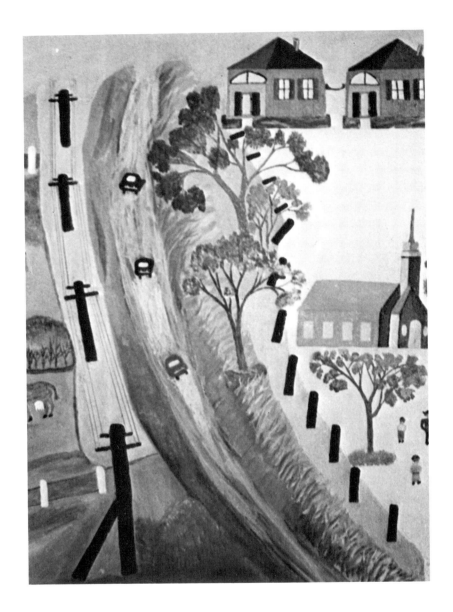

Figure 5. Detail of posts from *Village Scene* (fig. 36)

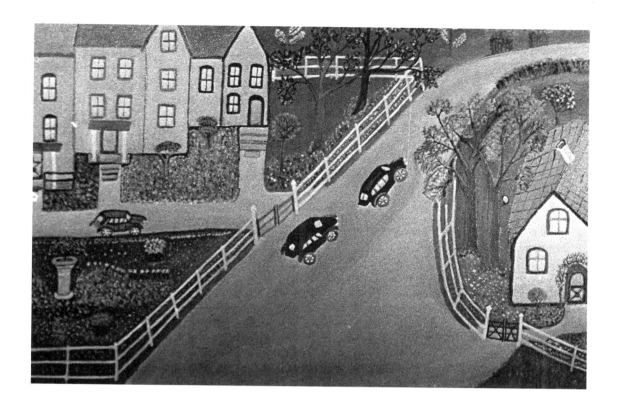

Figure 6. Detail of fence from *Two Cars Climbing a Hill* (fig. 77)

Figure 7. *Housetops*. Courtesy of Robert Allen Aurthur. Photograph by Bradley Smith.

the work, he failed to achieve a sense of volume. As he switched to the buildings on the left side, he created the illusion of fullness and dimension, especially in the buildings in the lower left corner. Yet as he improved here he did not succeed in painting the perspective of the houses in the upper left-hand corner, which appear to fall off the hill and out of the painting. Likewise figure 8, one of Pop's earliest watercolors, shows that he was initially unable to control wet colors. A later work (fig. 9), in spite of the fact that he had not mastered the phenomenon of placing objects on a hill in proper perspective, reveals a more assured hand which was learning to use the watercolor technique effectively.

Pop's comments concerning contemporary painters are informative as well as amusing. Pop believed paint should be applied smoothly and with great patience. Anyone foolish enough to put thick paint on the canvas was not worthy of the name of artist. Thus he remarked:

I don't like the modern way they throw the paint. I was in the city, Sandra told me they have some kind of new painting. If you paint heavy it shows and Danny told me, if you want to paint, you got to paint, the best painters, they paint very light. You know, you don't put paint on too much. You look at it, some paintings, you look close, they look terrible. You know, you look at some paintings, you look at them, it looks like lumpy. If you paint nice and smooth, it looks different.

You notice some paintings. There's a painter, my nephew, the one from Venezuela, he has a cousin, Zuca, a famous painter. . . . He's famous, he goes all over, every year he goes to different countries, Mexico, you know, he goes and paints in different coun-

tries. Well, he made a painting. When you are looking far away it looks all right, but you look close to it, I'm telling you, its terrible. . . .

He's a famous painter, but I could do better than that. . . . You look to a real good artist, you see everything is not lumpy. . . . He made a painting of his face, you looked at it from far away it looks all right—you look close, it looks terrible. You can see the paint laying on, now he's a famous painter, I was surprised. Maybe he knows what he's doing, I don't know. . . .[17]

Although he did not know it, Pop was actually reaffirming Bihalji-Merin's statement concerning the relationship between professional artists and naive painters.

The naive painters rarely continue traditional patterns out of respect for their formal values, nor do they take the work of professional artists for a model. The naive painters create spontaneously, unconcerned with public appreciation.[18]

An acquaintance of Pop's confirmed his lack of dependence on contemporary artists when she said, "He couldn't be bothered going to art exhibitions, he's not interested in keeping up with others, he's just happy doing his own thing."[19]

Signing, Naming, and Selling

Wiener's first paintings were signed I. Wiener. Later, when Grandma Moses died, he chuckled, "I started to call myself Grand Pa Wiener."[20] in order to carry on the Grandma Moses tradition. Sometimes this was spelled Grandpa. He frequently signed his later paintings Pop Wiener. Most

Figure 8. *Early Watercolor A*. Courtesy of Mrs. Sandra Weiner. Photograph by New York State Historical Association.

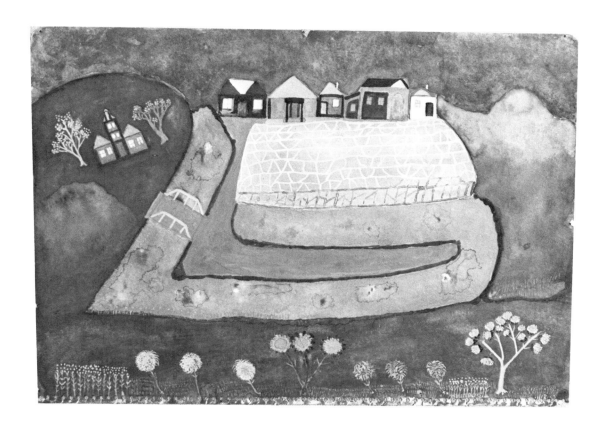

Figure 9. *Early Watercolor B*. Courtesy of Mrs. Sandra Weiner. Photograph by Bradley Smith.

of his paintings are dated in the right-hand corner, next to the Wiener signature. Pop did not name his paintings. He said, "I don't name them, I just paint."[21]

Grand Pa Wiener found it somewhat amusing that his paintings should sell. He sold his first painting quite by accident to the director of R.C.A. It was a ten-by twelve-inch ocean scene with a tower, which he had originally given to Danny. He described how it happened:

So, the manager from R.C.A. came up and saw it. She said, "I want you to sell me this painting." [Dan said,] "It's the first one my Dad made, so I want to keep it." "So," she said, "I'll give you thirty-five dollars." "So, if you want it," [Dan said], "you can take it." It encouraged me. [Dan said], "you [keep] painting, that's very good."[22]

Perhaps the selling of paintings was doubly amusing for Wiener because he spent most of his life struggling in order to make ends meet. Suddenly, in his old age, when he was not really in need of or concerned about money, he received it from a pleasurable activity like painting. He appeared to be completely unaware of the value of his work. In fact he did not really care if the paintings sold or not.

If they like them, they buy them, if they don't like them, it doesn't hurt me. I just paint. If I sell or don't sell, I paint just the same. I don't make them because I make anything. If money comes in, its all right, it comes handy. But if I don't sell 'em, I wouldn't stop painting.[23]

However this lack of anxiety about his work is one of the reasons Pop's paintings retain their charming naive quality. In this sense there is almost a spiritual tone about Wiener's paintings, a purity; they were created simply for the joy of creating. Contemporary society appreciates Wiener's paintings because of their freshness, simplicity, and directness. They are like a breath of fresh air in a complex world.

The first exhibition of Pop's work took place at the Bianchini Gallery, 16 East 78th Street, New York, March 26 through April 20, 1963. *Daniel in the Lions' Den* and *City Man with a Bull* were exhibited at this time.[24] Fifty-seven of Wiener's paintings were displayed in a one-man show at the New York State Historical Association, Cooperstown, New York from July through September 1970.[25] This show then traveled to the Albany Institute of Art in New York, and to the Museum of American Folk Art, New York City, in March 1971. A small exhibition of Pop's paintings has been scheduled for showing at B'nai B'rith in Washington, D.C., in the winter of 1974.

Characteristics

Wiener himself expressed the outstanding quality or characteristics of his work when he stated, "I like colors, you see everything I paint in colors . . . because colors give you a lively feeling, lively when you look at it."[26] He was like the great naive painter Henry Rousseau in this regard. He did not see things in light and shade, but rather, he expressed what he felt inside through color.

Bihalji-Merin wrote of Rousseau's creative expression, "Things and people were not experienced by him as light and movement. The integral parts of his inspiration were not only what is visible to the eye,

32

but also what is felt inside."[27] It could well be applied to Isidor Wiener's paintings.

The decorative and repetitive pattern is still another trait found in Wiener's work. Mrs. Judith Stanton, who has purchased several of his paintings, finds that there is an orderliness evident even in paintings of farm scenes, which one expects to be a bit untidy.[28]

Dr. Alfred Frankenstein, the art critic, finds that all objects are of equal importance in Pop's paintings. He commented, "It's an example of what Matisse said about every part of a picture having to work at every other part."[29] This overall pattern, however, is not peculiar to Wiener's paintings alone; it is inherent in the work of many naive painters. Stemming neither from the pleasure they take in the oscillating movements of the brush needed to produce such a pattern, nor in the results their strokes produce, the real reason for the frequency of this characteristic lies in the naive artists' attempts to illustrate each and every part they believe present in their subjects.[30]

There is likewise apparent in many of Wiener's works a definite point of view. It often appears as if the artist were on top of the composition when painting the subject. The photographer Jerry Cooke, who has also purchased some of Wiener's paintings, thinks their compositional qualities are significant and their lack of proportion makes them charming. In short, Cooke says, "Pop's paintings are fun."[31] The flat design and lack of perspective reappear constantly in each of his works. There is also a lively warmth and happy spontaneity which are especially evident in them.

These qualities, no doubt, have their source in Pop's love of and use of bright colors: red, green, blue, yellow, and brown. It is also quite likely, as Donald and Margaret Vogel write about the paintings of Aunt Clara, a naive painter from the west, that the vitality of Pop's creative expression stems from his "infinite delight in discovery and . . . vividness of imagination."[32]

When I asked Pop why he painted, he answered abruptly, "I paint because I paint."[33] He found it difficult to put into words something which, for him, demanded an emotional rather than intellectual response. However Pohribný and Tkáč, in examining the naive painter's motivation, have answered the question more fully. "The primitive is enchantingly straightforward and truthful," they write. "He works to please himself, or his dearest ones and to relieve his loneliness and he willingly shares his joy in doing so."[34]

Isidor Wiener boasted all three of these motivations. He said that he worked to please himself. "I paint because I paint" could not mean anything else. He also painted for his loved ones and found happiness in giving his work as gifts. "My grandson, in Long Island, he got married, I had to give him paintings," Pop said. "My granddaughter in Long Island, she got married, I had to give her paintings . . . whatever they like, they pick out, they are the bosses."[35]

We know that painting served to relieve his loneliness after the death of his wife: "It was almost a therapy for him," Sandra Weiner said.[36] Finally, Pop shared his inner feelings, through his painting, with all men. The Vogels, moreover, would call this sharing the greatest generosity of the naive painter. They wrote, "This is the

great generosity of the naive painters—that they share this inner life, these personal essences with us."[37] Pop Wiener painted because of a creative urge which brought him joy and relief, and at the same time allowed him to give something precious and intimate.

Reality

I was particularly interested in finding out whether Wiener painted what he saw or whether he was portraying reality in a symbolic manner. His reply to the question was the repeated statement, "Whatever comes into my mind, I started painting."[38] His daughter-in-law provided more insight into Wiener's view of reality when she stated, "He paints what he sees and how he feels about it."[39] This would lead one to believe that Wiener, whose paintings appear to the viewer as decorative works done by an artist from a contemporary school, was actually painting reality as he saw and felt it. Sandra's inference became more obvious when, in conversation with Pop, I asked him why he used the bright and varied greens so frequently found in his country scenes, in the trees, seen in *Three Birds in Springtime* (fig. 34). He replied, "trees are all different colors, trees [are] not all [the] same, when [you] go out to the fields, trees are not all the same."[40] This is a correct statement. If one looks closely at Wiener's trees, however, he will see that the colors are not those that most people would generally see in foliage. This statement points out that his pictorial rendition of reality is not necessarily the same as others'. Sidney Janis clarified the concept when he made the following statement about the naive painter's view of reality:

It's apparent from what they say about their work that they believe they are faithfully recording reality. However, even cursory examination shows a great disparity exists between what they believe and what they actually have accomplished. Although convinced that they have made a photographic reproduction of the world of reality, they have actually transmitted it into a pictorial reality.[41]

The reason that Wiener, like so many other naive painters, produced an original painting in spite of the fact that he thought he was painting a realistic representation of a scene, is because, "For the naive artist, the reality that he perceives and his idea of the picture are identical—just as among children and primitive peoples, who similarly do not distinguish between actual reality and their images of it."[42]

In a later work, Bihalji-Merin elaborated further on this question, revealing that the naive artist's view of reality is often overshadowed by his feelings about it. Thus, when Pop stated he had painted the foliage certain colors because it looked that way, he actually meant that he had painted it in this manner because of the way he felt about the trees, woods, and flowers.

In contrast to the modern, trained artist, he is trying to come to grips, not so much with the form of things as with things themselves. For him, the problem of the appearance of something and his reproduction of it is much less esthetic in character than it is technical. He wishes to depict what he has seen, what his eye or his spirit perceived: man or landscape, objects and dreams, events and visions are

not conflicts between light and dark, rhythm and space, although these elements may also be resolved unconsciously, through the medium of talent. They are rather questions of intensity of feeling, of a virtually instinctive will to express these things, to transfer them to the surface of wood, canvas or glass, to bring the act of creation to fulfillment in one's own work.[43]

Motifs

There are several themes and motifs which constantly recur in Pop Wiener's paintings. He frequently painted Bible scenes, often repeating Noah's Ark, the Crossing of the Red Sea, Adam and Eve, Moses, and the Ten Commandments, and Daniel in the Lions' Den. He also made several renditions of country village scenes, farm scenes, and seashore excursions. The seashore and village scenes picture people enjoying themselves on a holiday. Fun, frolic, and humor animate the faces of the people who appear in gay colors at the events. Wiener, like Rousseau, "tends to portray the common people in their moments of leisure."[44]

He likewise painted a few still lifes, a city scene and, after his assassination, a portrait of President John F. Kennedy. Among the motifs which continually reappear within these themes are miniature bridges, mountains, the horse and wagon, animals, trees, quaint houses, colorful and exotic flowers, fruits, and intriguing miniature people.

Regardless of the subject, whether it be a war scene, a cattle picture, biblical scene, or jungle painting, Pop Wiener always seems to invest these works with a colorful joy and a decorative simplicity. In this way he reveals the same kind of expressive spirit as Grandma Moses, who refused to share anything but her happiest memories with her viewers. Bihalji-Merin's analysis of Grandma Moses's work also sheds light on the creative talents of Pop Wiener:

To transmit one's experiences into a joyful affirmation of life presupposes a native gift of expression. Grandma Moses possesses that gift to a high degree. She picks out the best of her memories and shares them with us, with the friendly smile characteristic of her country, "What's the use of painting a picture if it isn't something nice?" she writes.[45]

It is especially significant to find that on the rare occasions when Pop's subject matter does have a dark or serious tone to it, for example *The Witch in the Woods* (fig. 44) and *Child Lost in the Woods* (fig. 32), the colors are still bright, gay, and cheerful. Even when a foreboding element appears in these paintings, like the fish that suddenly emerges in the waters of *Fun and Frolic* (fig. 86), or the lion that leaps at the lamb in *Jungle Scene* (fig. 71), they are still pleasing and joyful compositions. The viewer might think these surprises, which sometimes disturb the happy atmosphere of Wiener's work, reveal the hidden fears of the artist. A more likely interpretation is that they express an adult's view of childhood fears, although the brilliant color shows that they no longer hold their same import.

Sources and Influences

Wiener painted reality as he recalled seeing it in a particular source. An investigation of several of these sources, moreover, illustrates the variety of media and materials which appealed to and stimulated him. Memories of the old country, favorite television programs, an important event, a famous painting featured in the newspaper, a pleasurable stay at a resort town, recollections of *heder* days, are but a few of the images which flashed through his mind. In all of these scenes Wiener never copied and rarely made a preliminary sketch. Rather, his memory and mind made a copy which he later painted with a naive charm. This is true of the paintings entitled *Greek Revival in Hartford* (plate 8) and *Shelter Island* (fig. 83). Elizabeth Park (fig. 66) and the Greek Revival buildings of Hartford were both colorful and stimulating when he visited them about 1917 and later he painted the flowers and buildings in a decorative manner. Pop's vision of Shelter Island (fig. 84 is a contemporary photograph) inspired his painting of the same name. It was a view he recalled from the days he spent at Danny's summer home in Amagansett, Long Island, in the 1950s. He also painted *Lake Quassapaug* (fig. 79) from his memory of this Connecticut resort area where he and his family spent holidays in the 1920s; figure 80 shows how Lake Quassapaug looked at the time. All of these paintings illustrate how the ingenious artist relies on a particular scene only as a means to enrich his creative expression.

This is likewise true of appealing subject matter Pop found in magazines and newspaper articles. *The Bull* (fig. 63) was taken from a *Life* magazine photograph (fig. 64) and article.[46] A newspaper picture of Monet's *Terrace at Sainte Adresse* (fig. 61) was the source for *Copy of Monet* (fig. 60). Although there are certainly resemblances between these originals and Wiener's rendering of them, he actually has made something definitely his own. Even when he repeated the same subject, which he frequently did, as Pop stated, "I change something, you never do it the same way."[47]

The television too influenced Wiener's work. Many of his western paintings are scenes he retained from television series like "Cheyenne" and "Rawhide." The painting *Rawhide* (fig. 51) is an example of this.

Oftentimes Pop did not articulate the source of his motifs. This is especially true when dealing with the myriad of images which surrounded young Wiener in Russia and no doubt influenced his painting. Although it is impossible to sort out all of the elements which may have had impact on any artist's work, it is not inconceivable that Pop's earlier reference to the colors which raged everywhere[48] also encompassed the brilliant zone paintings on the exteriors of Russian Orthodox churches, the numerous icons on glass he could not have helped but see in the cottages of the peasants, and the general impact that an enduring naive Rumanian tradition may have had on him. The architectural decorations of doors and windows, the wooden utensils used daily by the peasants, even the outdoor shelters along the roads called *troiţa* were likewise carved and painted with the stylized decorative elements traditional to these people, and were certainly visible to Pop during the seventeen years he spent in his native country.[49]

All of this becomes more plausible when comparing the early nineteenth-century Rumanian icon on glass *Adam and Eve* (fig. 10) with Wiener's *Adam and Eve* (plate 1). Color, gesture, style, and feeling suggest a marked similarity. A glimpse at the Arbore Monastery, Moldavia (fig. 11) also reveals that the natural beauty of the Rumanian countryside was not the sole influence that produced the magnificent color in Pop's paintings.

At the same time Wiener could also be quite explicit about many of the European recollections which had influenced his painting. He retained a vivid impression of the illustrations from Russian textbooks, or comic books, as he called them, and they had a significant influence on his own artistic images. He remarked:

When I was a kid, I used to buy, the comic books, in the old country. They used to have nice paintings. I used to look at them. . . . The Russians you know, they used to have the Russians with big boots and different colors.[50]

He reiterated the deep impression the Bible stories had made on his paintings, and I wondered if, in spite of the fact that Pop lived in a community where only a few of the members were Jewish and an elaborate synagogue unlikely,[51] memories of the decorations of the country synagogue had not occasionally swept across his mind when he began to paint. His love of animals was nourished in the colorful plates found in the *National Geographic* and *Life* magazines. Visits to the Museum of Natural History also contributed to the detailed knowledge Pop portrays of many animals in his paintings.

Wiener often combined several memories into one painting. *Noah's Ark* (frontis-

Figure 10. *Adam and Eve*, Rumanian icon on glass. Reprinted, by permission of the Rumanian Library, New York City, from Irimie and Focşa, *Icoane Pe Sticlă*, fig. 19.

Figure 11. The Arbore Monastery, Rumania. Courtesy of the Rumanian Embassy, Washington, D.C.

piece) is obviously a boyhood memory from the Bible. The ark itself, however, was actually an image he saw in Amagansett of a house on pilings (fig. 12) which seems to rest on thin posts. The animals in the detail from *Noah's Ark* (fig. 13) are probably his memories of magazine pictures and museum exhibits. It is also possible that they could be a faint recollection of the decorative animals which caught the boy's attention as he examined the Torah ornament. The most intriguing aspect about the source of this painting rests in its pattern. The arrangement of the animals, although typical of the zone perspective the untrained artist uses, has a real tapestry-like quality about it. Pop definitely recalled the tapestries which hung around the homes of the Rumanian peasants.

They made different patterns, they loved rugs there. Rumania. . . . If you come into a peasant's [house] that all you could see was rugs on the walls, on the floors, they didn't have no beds. . . . You know, when you come to a peasant those days in village, they used to get friends, they would have a special room where they used to sleep, all with carpets, rugs, that's a nice room.[52]

It is quite likely that the birds of Rumanian carpets, such as the one in the carpet from Bucharest in figure 14, could have unconsciously influenced his patterns of stylized birds perched on the top of the ark (fig. 15).

38

Figure 12. House on pilings, Amagansett, Long Island, 1969

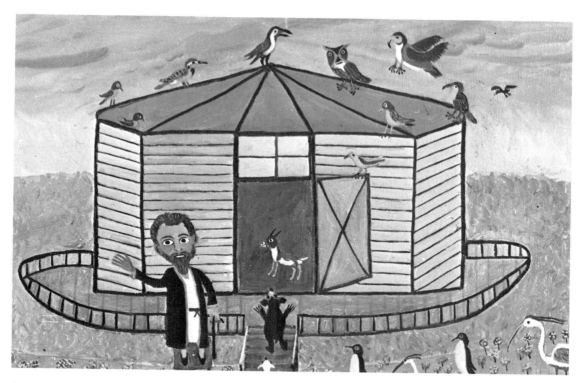

Figure 13. Detail from *Noah's Ark* (frontispiece)

Figure 14. Carpet from Bucharest. Courtesy of Verlag Ernst Wasmuth and Praeger Publishers.

Figure 15. Detail of birds from *Noah's Ark* (frontispiece)

Rumanian Folk Art Tradition

Mioritic Space

Before delving into the influence of Rumanian carpets upon the work of Pop Wiener it is first necessary to understand the philosophy upon which much of Rumanian folk art is based. A comprehension of this concept of Mioritic space serves both to confirm this relationship and provide further insights into many of Wiener's paintings.

Mioritic space can be defined as the space where the ballad *Miorița*,[53] as well as the philosophy it engendered, was born. In the early centuries of barbarian invasion in eastern Europe, a small area of Rumania was preserved from infiltration because of its geographic location. Later named Transylvania, this territory was protected by the Carpathian Mountains, the Danube River, and the Black Sea, enabling the shepherds who inhabited it to preserve an ancient culture. In this secluded enclosure the people created the ballad *Miorița*, which explained the phenomenon of life, death, and mortality in relation to man and nature.

It further exemplified the affinity with nature which grew up among these people, whose lives were protected by the hills and whose needs for friendship were fulfilled by their brother, the woods. Every man, tree, animal, and flower was part of nature, which was guided by the God above. This concept was the source of a realistic view of life and death in which nature would also share in the joy of resurrection. Unlike the Hellenic theory which placed man above nature and saw death as the destruction of humanity, the Rumanian philosophy of *Miorița* established a harmony between man and the elements and an instinctive hope of renewal stemming from man's belief in God and trust in nature.

The significance of this concept is apparent in all Rumanian folk art, with its frequent use of nature motifs and the integration of these motifs with one another. It is also obvious in the paintings of Pop Wiener, whose work reflects the influence of Rumanian folk art. This is particularly noticeable in Pop's frequent use of what appear to be Rumanian carpet patterns.[54]

Rumanian Carpets

There is a resemblance between the patterns of flowers Wiener includes in so many of his paintings and the flowers and fruits of Rumanian tapestries. The detail of the flowers (fig. 16) from the painting *The Gateway* (fig. 82), and the Rumanian flower carpet from the Oltenia region (fig. 17), the detail of an eggplant (fig. 18) from Pop's *Eggplant Tree* (fig. 56), and the carpet from Bucharest by Aurelia Ghiată (fig. 19), support this point. The same lacy, linear patterning is used in *The Gateway* and the Oltenia carpet. The tree in the tapestry by Ghiată closely resembles Wiener's *Eggplant Tree*. The similarity becomes more obvious when one studies but a few of the characteristics of Rumanian folk art as they appear in woven tapestries and embroideries.

Abstract Harmony

We have already spoken of the decorative quality of Wiener's works. He did not paint as an academic painter, concentrating on perspective to create a three-dimensional

Figure 16. Detail of flowers from *The Gateway* (fig. 82)

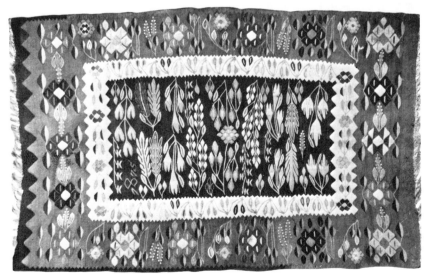

Figure 17. Rumanian flower carpet from the Oltenia region. Reprinted, by permission of the Rumanian Library, New York City, from Focşa, *Scoarţe Româneşti*, p. 172.

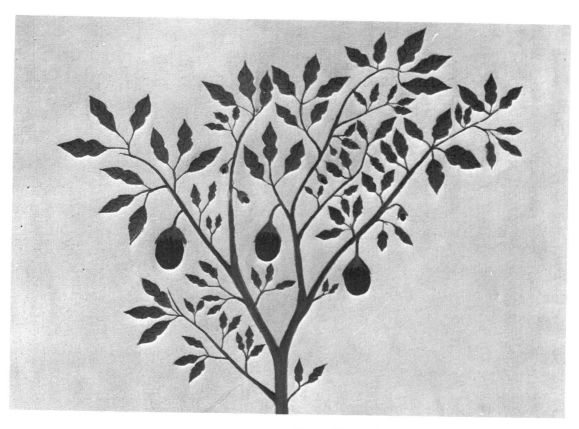

Figure 18. Detail from *Eggplant Tree* (fig. 56)

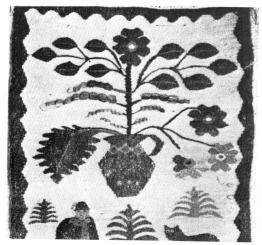

Figure 19. Bucharest carpet by Aurelia Ghiață. Reprinted, by permission of the Rumanian Library, New York City, from Focșa, *Le Musée d'Art Populaire*.

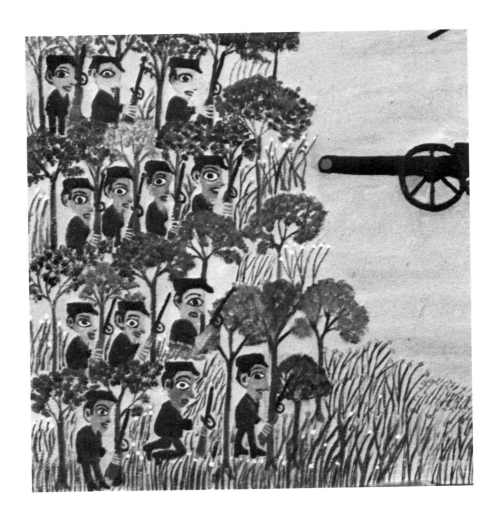

Figure 20. Detail from *Korean War Scene I* (fig. 74)

work. Rather, he painted in an abstract, two-dimensional pattern. He even executed his figures in this decorative manner. These characteristics are quite evident in an interesting detail from *Korean War Scene I* (fig. 20). A definite harmony of design is also evident which does not allow any aspect of the pattern-like play of soldiers to predominate over any other. The colors are bright and lively, but they blend into a well-rounded whole. The painting bears a resemblance to the kind of carpets Wiener may have seen on Rumanian peasants' walls. This description of Rumanian folk tapestries calls to mind Wiener's *Korean War Scene I* (fig. 74):

Take for example the beautiful carpets, mats and tapestries woven by Roumanian housewives to drape the benches and walls of their simple little houses built of straw and earth. Coloring varies from region to region, ranging from the bright reds and yellows of Oltanian tapestries, to the darker hues of old Bessarabian carpets; yet they all display the same perfect harmony of design, the same simple figure-drawings and the same abstract style of artistic expression.[55]

Idealization of Nature

This resemblance is even more obvious when observing the way both Wiener and the Rumanian peasant artist treat nature: "The most striking feature of the Roumanian embroideries and needle work, in general, is an idealization of the shapes which nature has to offer and an avoidance of lifelike reproductions."[56]

If one looks closely at several of Wiener's works in which he has included the beauties of nature, one will notice that he has represented them in an ideal or abstract

way. The detail of a tree (fig. 21) from the painting *Ginger* (fig. 53) illustrates this point. This is certainly a tree, but it is a tree whose leaves appear unreal or ideal. Wiener has painted the idea of a tree rather than a photographic reproduction.

Geometrical Patterns

Wiener's floral patterns also show a resemblance to those found in Rumanian tapestries. H. J. Hansen made the following statement about the geometric quality of Rumanian carpets:

There is a certain degree of uniformity in the ornamentation and the styled floral patterns; there is a tendency for all patterns to be geometrical, even when the dominant motifs are flowers. The range of colors is rather limited everywhere, consisting in the main of red, green, yellow, black and white.[57]

One glance at a detail (fig. 22) of Wiener's *Mountain Scene* (plate 5) shows the resemblance. The dominant motif on the mountain is a flowerlike arrangement of colorful trees which appear to be in a geometrical, triangular placement. In spite of their apparent angularity, they fit nicely into the rounded mountain. This is likewise true of floral patterns in *The Gateway* and in *Greek Revival in Hartford* (detail fig. 23).

Poetic Expression of Nature

Uniformity in ornamentation, however, does not mean that individuality is lacking in either the tapestries or Wiener's work. In fact, the World's Fair catalogue of 1940, *Roumanian Peasant Art*, has this to say about the unique poetic aspect of Rumanian tapestries:

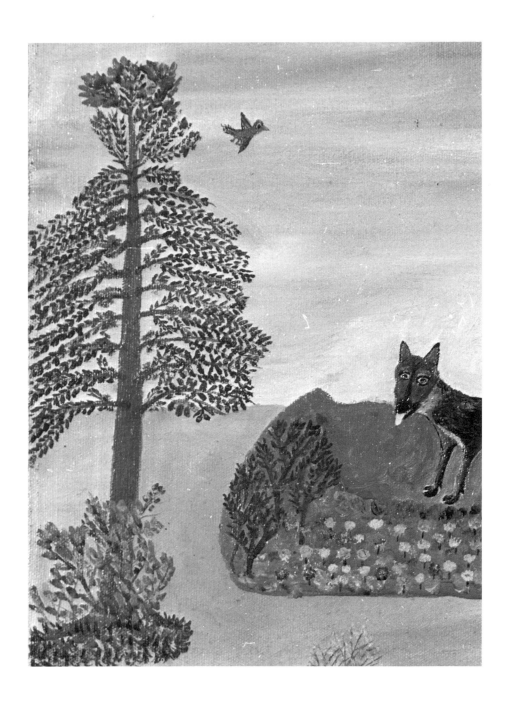

Figure 21. Detail of tree from *Ginger* (fig. 53)

Figure 22. Detail from *Mountain Scene* (plate 5)

Figure 23. Detail of flowers from *Greek Revival in Hartford* (plate 8)

Figure 24. Detail of flowers from *Child Lost in the Woods* (fig. 32)

Each tapestry has an individuality of its own —a simple, but genuinely poetic expression of nature. The leaves of plants may look like wings and birds, like flowers. Flowers may resemble butterflies and wierdly twisted branches, seem like mysterious, primitive writing—the secret hieroglyphics of a nation's innermost thoughts.[58]

So, too, does the detail of entangled flowers and branches (fig. 24) from *Child Lost in the Woods* (fig. 32) appear like a "mysterious primitive writing." The twisting, winding trees to the left of the path look as if Wiener were attempting to paint what the catalog calls "a simple, but genuinely poetic expression of nature."

Figure Motifs

The phenomenon does not end here. Even in the choice of subject matter one might say there is a relationship between Rumanian tapestries and Wiener's naive paintings. The 1967 catalog of the *Folk Art Museum of the Socialist Republic of Rumania* sums up the figure motifs prevalent on tapestries:

The geometrical motifs prevalent in these wall carpets do not exclude figure motifs. Conventionalized in a very original manner with characteristic simplicity, these motifs: horsemen, women, spinning, people riding on horseback, the round dances, women with distaffs, a shepherd leaning on his club while watching his sheep, etc., are daily scenes typical of the region.[59]

Paintings like Pop's *Horse and Cart* (plate 6) are typical of the figures on wall carpets the catalog from the Bucharest Museum mentions. But even paintings like *Man in*

Boat (fig. 75), although obviously taken from a summer resort in the United States, reveal the same homespun, everyday quality which is so much like the motifs pictured on Rumanian carpets.

Jewish Painting Style

It is important to note that although several of Wiener's paintings have their origin in Old Testament subject matter (frontispiece, plates 1, 2, 3, fig. 30) they do not, on the whole, reflect a Jewish tradition in painting. In spite of what has already been said and observed about Wiener's Jewish perspective on life, his paintings are not born of a deeply Orthodox vision, a set of religious values which would seem to permeate the very structure of the works. A comparison of Shalom of Safed's painting of *Abraham and the Nine Kings* (fig. 25) with any of Wiener's biblical scenes clarifies this point.[60]

It is true that Wiener stemmed from the same spiritual ambiance as Shalom. But unlike Shalom, who lives in Israel, Pop came to the United States at an early age, severing the remaining religious bonds he held with the Jewish Orthodox tradition. He immediately became immersed in a new culture and his views grew to reflect what his paintings later would depict, a mixture of conceptions, aspirations, and impressions, in short, a new manner of looking at life.

Shalom's work, on the other hand, has always been steeped in the Jewish tradition of painting. According to Daniel Doron, the man who discovered Shalom and is presently his agent, "Shalom's work can best be characterized by its stress on wholeness, action and intimacy, and its lack of interest in formal perspective and ideal representation."

Wiener's paintings lack this sense of wholeness, for they depict a particular moment in time. In Shalom's *Abraham and the Nine Kings* the viewer partakes of the entire biblical event and thus realizes its significance and meaning for all mankind. In Wiener's *Moses and the Ten Commandments* (plate 2) one catches a glimpse of an event whose whole relevance is not obvious in one glance. Wiener does not paint in order to illustrate the history of the Jewish people.[61] It is not his wish to tell the endless story of existence in colorful zones which are painted in the direction of the Hebrew script. He has little interest in portraying the universal significance of Moses' giving the Commandments of God to the Jews. Instead, Wiener's main interest is in sharing the nostalgia of Torah study at the *heder*. It is a brief look, one of a vast store of memories emanating from the brush of a man whose circumstances in life could not possibly have enabled him to have the vision so apparent in the work of Shalom.

Shalom's paintings convey a feeling of condensed space which does not tend to create an illusion of a real environment. They are a reflection of his own inner vision which sees reality as an expression of God's working in history. Wiener's view, on the other hand, is one that reflects considerably the concrete actuality of the everyday world we live in. The detail of trees and flowers, present in Wiener's *Adam and Eve* (plate 1), are omitted in the painting of Shalom. For Shalom, the patterns and rhythms objects create are more important than the speci-

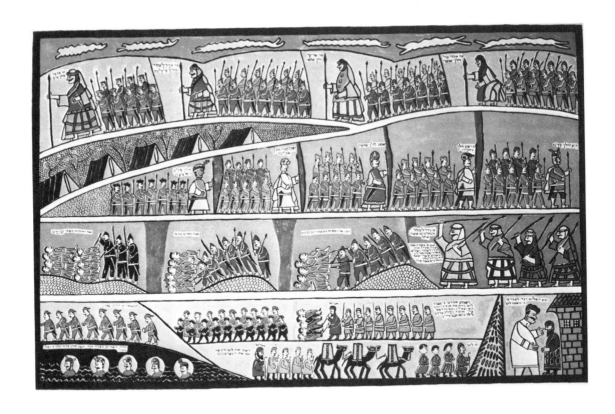

Figure 25. *Abraham and the Nine Kings*, by Shalom of Safed. Courtesy of Daniel Doron.

fic details intrinsic to them. In the work of Isidor Wiener there is ample evidence of the physical realities which made life in the United States so meaningful to him. For example, in *Crossing the Red Sea* (fig. 30) Wiener makes a definite attempt to visualize depth and create the illusion of space in his work.

Even so, there is a slight indication of the Jewish tradition in the work of Pop Wiener. Although the importance of these elements should not be overemphasized, close examination of Pop's painting, like Shalom's, reveals humor and intimacy. The immigrants boarding the ark in *Noah's Ark* (frontispiece) are dressed in the type of clothing Wiener probably wore on his journey to the United States. The inclusion of the clothing, and the World War II tents in Shalom's *Abraham and the Nine Kings*, establishes a rapport with the viewer which enables him to experience the living aspects of scripture, as well as the integration of past, present, and future in history. The humor in both of these artists' work is apparent in their interpretations of the biblical stories,[62] as well as in the delightful characters they have created.

A comparison of the action in Shalom's and Wiener's painting results in further distinctions between the styles of these two artists. It is quite noticeable that the individuals, their faces and movements in Wiener's *Noah's Ark*, for example, force the viewer to take note of each separate person and the activity he is engaged in. Shalom's *Abraham and the Nine Kings* depicts many individuals carrying on a variety of movements which do not, however, detain the viewer from comprehending the entire event. They are, more or less, part of the patterning of the work.

We may therefore say that in spite of the subject matter and a certain capacity for intimacy in his painting Pop Wiener does not paint in the Orthodox Jewish tradition. Lacking the sense of integrity which flows from the brush of one whose religious tradition has remained operative, Wiener's painting manifests, instead, what may be called an American-Jewish spirit. It reveals a juxtaposition of cultural influences which have altered his vision but, at the same time, have been instrumental in the creation of naive paintings which declare Wiener's sense of joyful fulfillment and delight in having become assimilated in the American cultural tradition.

4

'He paints that way because he is that way'

The Old Country

Many of the paintings which Wiener created reflect his early life in Russia and Rumania. They were, for the most part, painted at the beginning of his career and rely heavily on his memory. The themes are usually religious or pastoral. All the pictures reveal the life and character of Pop, the man who painted them.

Religious Themes

Adam and Eve (plate I)

This brilliantly colored view of the Garden of Paradise demonstrates that the biblical stories young Wiener learned in the Jewish school and perhaps saw the Rumanian peasants painting under glass (see fig. 10) made a lasting pictorial, as well as intellectual impression on his life. He has painted each detail of this history-making moment with exactitude and love, yet it is not lacking in the humor which is so characteristic of his personality. Adam peers out at us from behind a branch with wide eyes and a half-grin as Eve is about to pluck the forbidden fruit from the richly decorated tree. He appears like a jester in a Shake-

spearean play, who serves both to add a touch of humor to the story and to warn us of a foreboding event. In the explanation of the painting Pop reinforced the humor. This was especially true when asked why he had set Adam and Eve so apart from each other on the canvas. I naturally had expected an answer based on an aesthetic reason. He simply replied, "I can't put them together, so I had to put them apart."[1]

Particularly noticeable in *Adam and Eve*, as well as other biblical scenes painted by Pop, are the large haunting eyes of the subjects. Several explanations are available to explain their presence. A fellow countryman of Wiener's, Morris Gertz, remembers seeing the large glass eyes of biblical characters "shining like a man looking at you,"[2] in the decorative Torah ornament. Although it is quite possible that Pop too remembered the Torah decorations from his synagogue training, it is likely that he was influenced by the commercial art of Walter and Margaret Keane,[3] which has had such a tremendous impact on the media in the United States. A glance at a magazine or a stroll through the supermarket would have placed Pop in immediate confrontation with these images. The

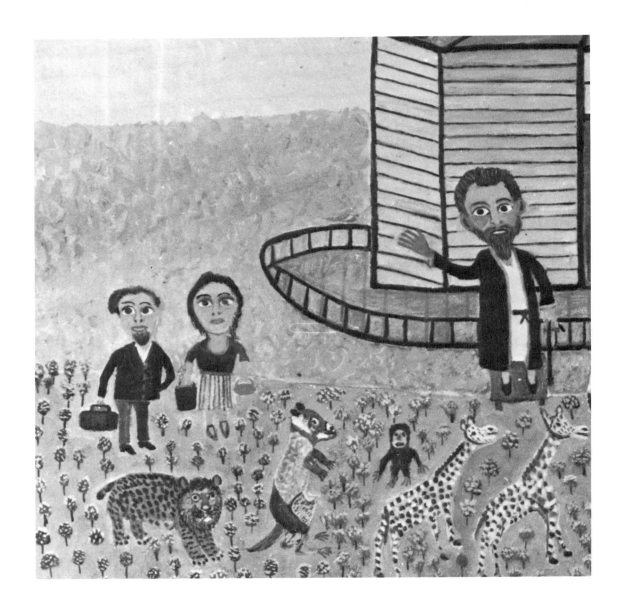

Figure 26. Detail of couple boarding from *Noah's Ark* (frontispiece)

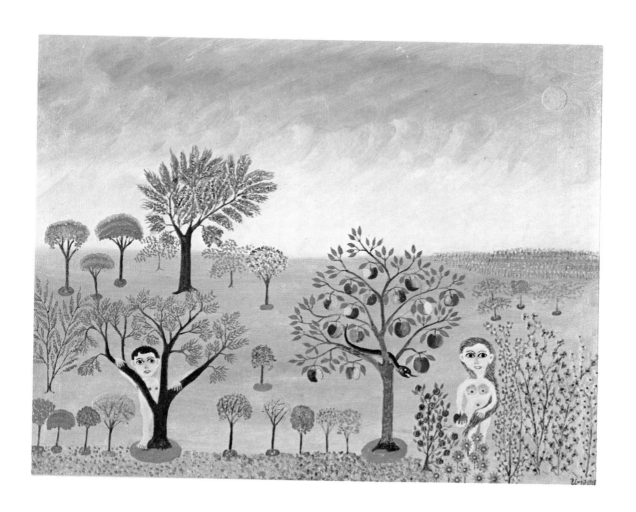

Plate 1. *Adam and Eve*. Courtesy of Bradley Smith. Photograph by Bradley Smith.

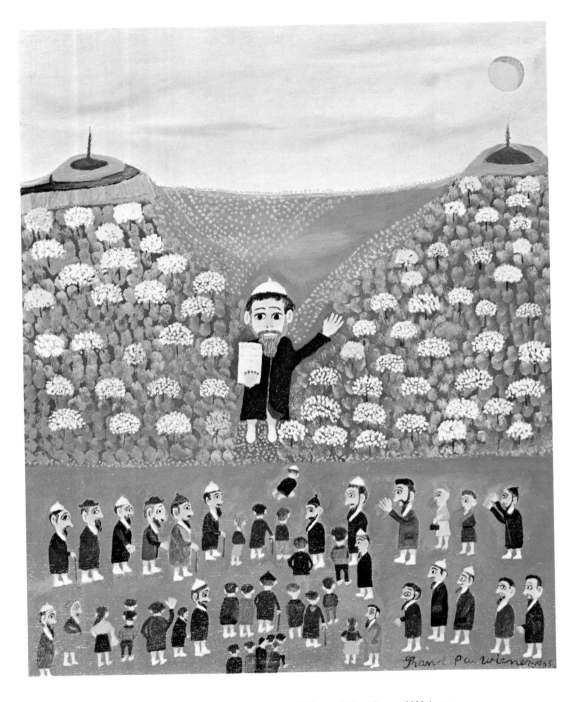

Plate 2. *Moses and the Ten Commandments*. Courtesy of Mr. and Mrs. Samuel Weiner.
Photograph by Fallsburg Printing Company, South Fallsburg, New York.

most plausible explanation seems to be, however, that Wiener, raised in an atmosphere where Byzantine frescoes were very conspicuous, still retained the memory of those almond eyes which are a feature of figures in Byzantine art.

Noah's Ark (frontispiece)

This is another of Wiener's delightful biblical themes. He repeated it several times and each repetition reveals not only the artist's love of animals and religious heritage, but also pleasing aesthetic qualities. The only adequate description of the color in this painting is *exciting*. The rich blue of the water is repeated in the clumps of grass and growth on the land, and the various shades of brown and green of the coats of the animals are intriguing. The ark almost moves in space; this is because of its combined two-dimensional front and three-dimensional sides. The interesting shapes of the birds contribute to the decorative character of the entire painting. All the animals and objects in *Noah's Ark* receive the same attention, but the activity of the animals does not detract from the central theme and figure of Noah. The detail (fig. 26) of a couple boarding the ark dressed in contemporary clothes, shows that Wiener, like the French naive painter Auguste-André Bauchant, had the "ability to combine the sublimity of the ancient world with a feeling for the contemporary scene at its most ordinary. . . ."[4] By putting these two immigrants into *Noah's Ark*, Wiener showed that he agreed with contemporary theology as well as the Jewish tradition, which seeks to make the Bible living and meaningful.

Sculptured Birds (fig. 27)

Pop frequently wanted to give the animals he painted, such as the birds in *Noah's Ark*, greater veracity. Whether he was motivated by Rumanian folk literature, which frequently employs the bird as a symbol of human passions,[5] or a desire to see the birds come alive, he was able to accomplish this through the medium of sculpture. This medium had the added advantage of freeing him from painting the third dimension.

Wiener's dexterity and spontaneity within this medium, in spite of a lack of training, showed that he became assimilated into the spirit of American folk sculpture.[6] He chose plastic wood, a material which was accessible and pliable, and began to sculpt these enchanting birds. He explained his technique with his usual candor and enthusiasm. "I take a plastic wood, then I carve 'um out, paint them out, shape 'em out . . . knife jack, I have some special tools . . . plastic wood comes in cans. I buy cans in the dime store."[7]

Moses and the Ten Commandments (plate 2)

In this painting the design of the two hills, which reaches a vanishing point where Moses stands, heightens the impact of this well-known story. Likewise the size of Moses in proportion to the Israelites below contributes to the drama. *Moses and the Ten Commandments* is an excellent example of how the naive painter, like the contemporary expressionist, distorts paintings because of the way he feels about them. The expressionistic painter distorts deliberately, however, while Wiener does this unconsciously. In spite of the excellent design and the intensity of feeling ex-

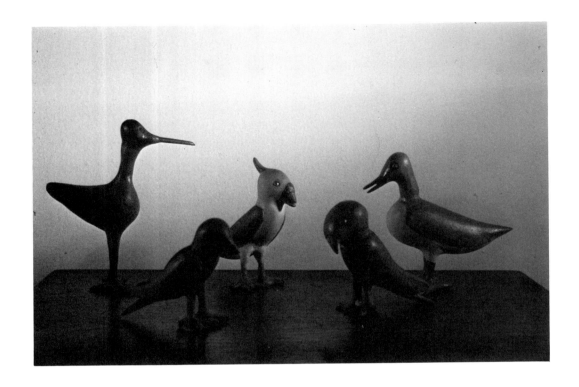

Figure 27. *Sculptured Birds*. Courtesy of Mrs. Sandra Weiner. Photograph by New York State Historical Association.

pressed in this painting, Wiener preferred to emphasize its humor when questioned about it.

This is Moses, he come down from the Mount Sinai with the ten commandments. Here's all the Jewish people, they're meeting him there. See they all wear socks. It's a holy place around Mount Sinai. They have to take their shoes off. And when they come down from Mount Sinai, they left their shoes far away. The Arabs stole their shoes, the Egypts stole their shoes, they didn't have no shoes to go home.[8]

When I asked why he had the Israelites arranged in two close rows which come to a point at the bottom of the painting, he answered, laughing, "You know the Jews stick [together] like. . . ."[9]

Daniel in the Lions' Den (plate 3)

The seriousness with which Wiener spoke of this painting was in great contrast to his treatment of the other biblical themes. This may be because he had named his third son, who had died in an airplane crash, Daniel. One can sense from the Jewish legend Wiener told to accompany the painting that he regarded Daniel as a man to be admired and imitated, but not laughed at.[10]

According to the Bible, the Bible says, and they throw him into the lions. When he walked into the lions, there was one lion there, the Bible tells you. When he was wounded, when he went away in the jungle, he came to a place where a lion was laying and moaning. He had a splinter in his leg. So, he went and pulled out that splinter from the leg and ban-

daged the lion and he stayed there with the lion for a long time.

The lion; he got acquainted with the lion, the lion took a like to him because he saved him when he was in pain. So the lion used to go out and hunt for food . . . like he used to catch rabbits and different animals and he used to eat just what the lion used to eat.

They caught him, Daniel. They had a trial, they decided to throw him into the lions. They wanted to see if he's a man, he's so strong, he could speak different languages. He claimed he could speak to birds, and to lions and, you know, according to the Bible. So, they throw him into the lions and when the lion, that lion; they caught that lion, they throw the lion in the cave where they kept the lions.

So, when they throw him in to the lions, the lion that he saved, you know, from the pain and all, recognized him. All the lions that were [in] that cage, like a cave there, cage, they kept lions there. And that lion, as soon as he saw him and recognized him, you see, the lion the first lion . . . he recognize him, and he kneeled, and the other lions saw that, you know, they all got kinda excited, they didn't do nothing; they didn't attack him. He's kneeling because he's a king, he saved him from all the pain.[11]

It is noteworthy that Wiener spoke of the lion as if he were human. It is even more significant that the lions actually have human expressions as figure 28, detail from *Daniel in the Lions' Den* shows. Each face seems to manifest a distinct personality as the animals move in and out of the den. It is quite likely that the Bible, as well as Rumanian and Jewish folk stories, which treat the animal as a disguised human being,[12] influenced Pop in this personifica-

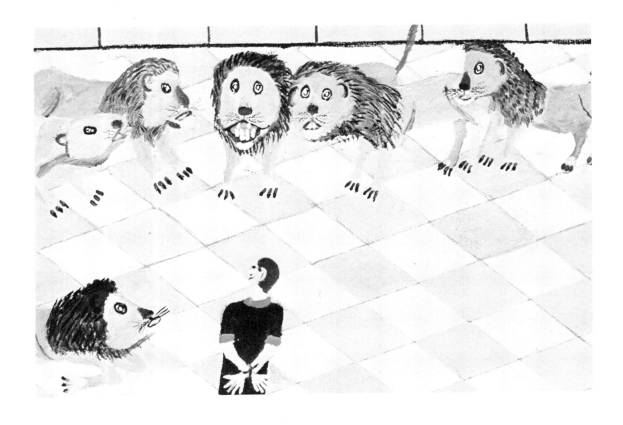

Figure 28. Detail of lions from *Daniel in the Lions' Den* (plate 3)

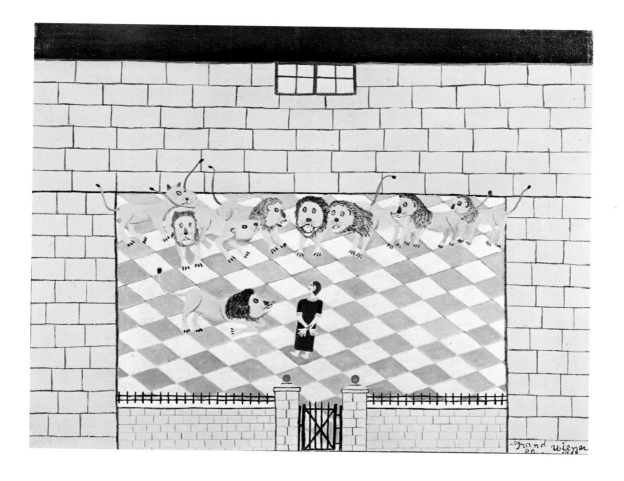

Plate 3. *Daniel in the Lions' Den*. Courtesy of Mrs. Sandra Weiner. Photograph by Bradley Smith.

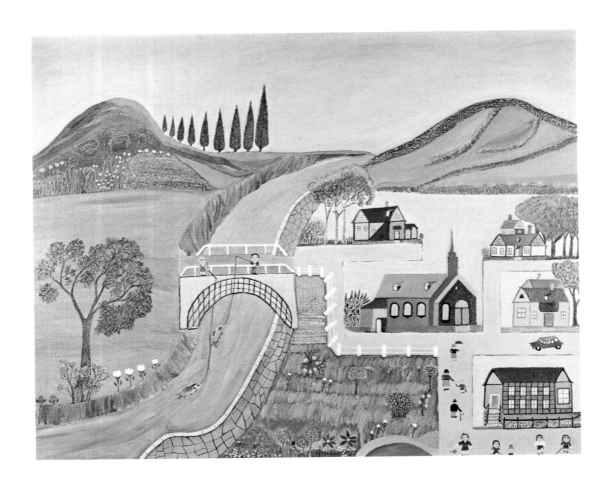

Plate 4. *Church in the Valley*. Courtesy of Mrs. Sandra Weiner. Photograph by Bradley Smith.

tion. But probably the most important influence was Wiener's love of animals, which inevitably revealed itself in his depiction of them.

The Lion (fig. 29)

Pop's rapport with living things is likewise unmistakable in the charming, capricious lions, which he formed from plastic wood: a small boy's memory of the folk ornament surrounding the pages of Bible story books, transformed many years later into authentic works of naive sculpture.

Wiener sculptured many lions; the one shown in figure 29 is perhaps the finest. As with any true piece of sculpture it evidences a unique relationship with the space which envelops it. In fact the space and the shape which this anthropomorphic animal creates about it is as significant as the form of plastic wood from which it was made. A glance at the pleasing curve of the lion's back and the exquisite shape it impresses on the circumambient atmosphere suggests that Pop, in his naive manner, was as adept with the medium of sculpture as he was with painting.

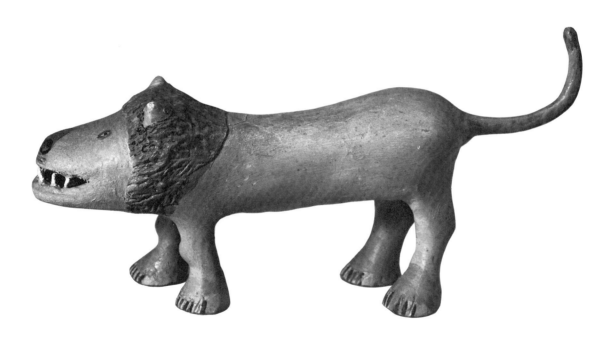

Figure 29. *The Lion*. Reproduced through courtesy of the New York State Historical Association.

Figure 30. *Crossing the Red Sea*. Reproduced through courtesy of the New York State Historical Association.

Grand Pa. Wiener. 1967.

Crossing the Red Sea (fig. 30)

Wiener related his vivid childhood recollection of this biblical story:

When Egypt led the Jews out from Egypt, when Moses took them out from Egypt and they crossed . . . the Red Sea and then Egypt, you know, felt sorry why she let 'em out, she give 'em you know, lot of stuff to take along on the way. And then they chased 'em in the ocean. They crossed the ocean, and then the Egyptians chased 'em, see. Every time they got in the sea, they got drowned there. That's from the Bible, you know.[13]

He has visually presented this biblical theme, too, through the use of intuitive aesthetic devices. The division of the painting into three sections lends itself to the theme of the story. The half-circular form of the Egyptians with swinging swords makes a moving and twisting pattern in the water, which connotes the element of struggle which these men faced as the waters of the Red Sea overcame them. Figure 31, detail of an Egyptian chariot, illustrates the motion toward the sea. The full foliage on the side of the Promised Land, in contrast to the leafless bushes on the Egyptian side, is symbolic of the productivity which awaits the Jews. The contrast between the bright colors of the Egyptian side and the subtle blue, grey, green, brown of the other side contributes to the division of the painting. At the same time the specks of red decorating the chariots to the left and the children on the right lead the eye of the viewer across the painting with the Jews to the Promised Land. Finally, the rounded edges of the Israelite side of the painting are in marked

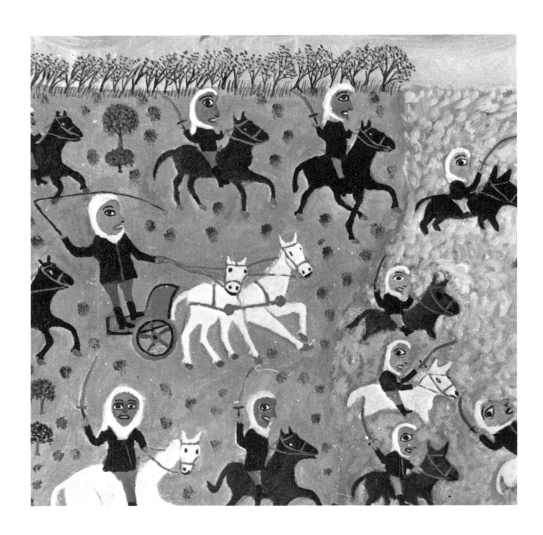

Fig. 31. Detail of Egyptian chariot from *Crossing the Red Sea* (fig. 30)

contrast to the squared character of the Egyptian side.

Also particularly noteworthy in this painting is the artist's indirect reference to his Rumanian cultural heritage by including elements of Rumanian folk costume and folk life. According to Israil Bercovici, secretary of the Romanian Theatre in Bucharest, the two-wheel cart, the striped skirts worn by the women, and the decorative sash around Moses' waist are all typical Rumanian motifs.[14]

Images of the Past

Child Lost in the Woods (fig. 32)

The dreamlike painting of a little girl crying in the woods looks very much like the work of Marc Chagall. Wiener, when speaking of this painting, referred only to the literal meaning it portrays. He said, "The child is lost somewhere in the woods, so she was going and crying and while she was crying, the angels were guiding her."[15] However, the protective cocoon which the angels, trees, and road form around the little girl, the hazy bluish-green color, with the decorative patterning of the path, footprints, and leaves, and the curvilinear trunks repeated in three distinct rows, all give the painting an eerie, other-world quality.

The presence of all of these components suggests the artist's exposure to the philosophy of *Miorița*[16] explaining the Rumanian peasants' relationship with nature, God, and man. This philosophy may well have been influential in Wiener's conception of a forest which shelters the child from evil and whose protective trees and branches demonstrate why numerous Rumanian folk tales have, through the centuries, begun with incantations to nature.[17]

When asked if this might not be a memory of his little three-year-old sister, who continually cried for her dead mother, Pop replied simply, "It could be, yea, a lot of things you forget."[18] His reply discouraged further consideration of the psychological characteristics of the work and further discussion centered on the design of the painting.

Wiener's flowers resemble those of the Yugoslavian naive painter Ivan Rabuzin.

Figure 32. *Child Lost in the Woods*. Courtesy of James O. Keene. Photograph by New York State Historical Association.

Figure 33. Detail from *Child Lost in the Woods* (fig. 32)

Like Wiener, Rabuzin's floral arrangements reveal the same characteristics as peasant tapestries. Bihalji-Merin's description of Rabuzin's work could well be used in reference to this detail (fig. 33) from *Child Lost in the Woods*. "His strange monumental flowers . . . are . . . dream images crocheted with a needle, like those gaudily embroidered cloths that the peasants in Slovenia and Croatia made for their weddings."[19]

Three Birds in Springtime (fig. 34)

This fresh and lovely painting is one of Pop's farm scenes which was at least partially inspired from the artist's memories of the old country. This is particularly visible in the Rumanian peasant houses nestled in the agrarian landscape[20] and the three birds soaring over the flocks. In Rumanian folklore the occurrence of flying birds can be interpreted in several ways. Moses Gaster would see an ominous connotation in this painting. He wrote in *Rumanian Bird and Beast Stories*, "If ravens or crows croak over a flock of sheep, the shepherd keeps a double watch, for they [the Rumanians] believe the ravens or crows foretell an in-road by wolves or other wild beasts."[21] This interpretation seems inappropriate, however, in the presence of such optimistic color. A more fitting explanation is the bird-soul theory that at death mens' souls turn into birds which rise to the sky.[22]

The painting is further characterized by a naive charm which is especially evident in the pleasing awkwardness of the figures in the foreground, the patterns created by the sheep and trees, and the wonderful use of "springtime" color. Pop's reply when

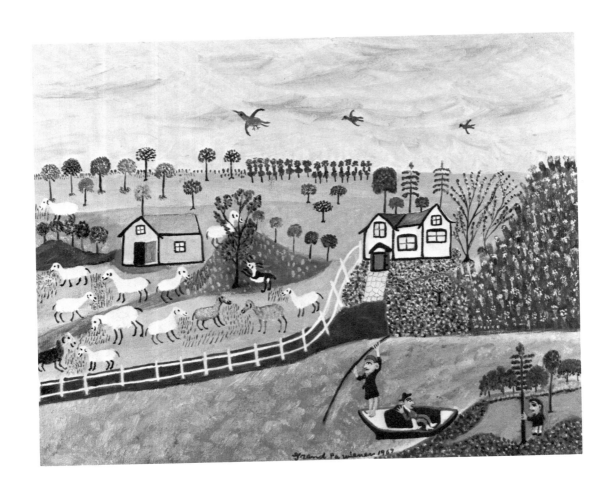

Figure 34. *Three Birds in Springtime.* Courtesy of Mrs. Sandra Weiner. Photograph by Bradley Smith.

asked why he used the exciting bright colors in the background trees was:

Well, the trees are all different color trees, they are not all the same. You go out in the field, you go out in the park, some place, don't you see different, some trees are orange, white, yellow, you know, all these different colors. . . . Girls are the same, some are brown, some are dark, some are white.[23]

The tree pattern is an excellent example of the naive painter's intuitive aesthetic sense. Wiener merely filled in the empty spaces in the background with trees. Unconsciously, however, he has created this pleasing pattern. This is likewise true of the sheep in figure 35. The naive artist has found in the arrangement of their small feet a formula which provides him with a sense of security. Although he varies the direction of the feet, he is unaware of the artistic merit of the pattern he has created.[24] In this painting too, there is a resemblance to the tapestries of the Rumanian peasants. Bihalji-Merin's statement about the work of Meroslav Marinkovíc, a Yugoslavian naive painter, would also prove to be an excellent description of Isidor Wiener's *Three Birds in Springtime*: "Naive and vigorous strokes hold the modulated decorative colors well in hand. Woods, clouds, human faces and flocks of sheep are treated with equal emphasis, interwoven as in a tapestry."[25]

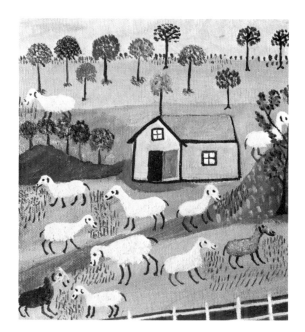

Figure 35. Detail of sheep from *Three Birds in Springtime* (fig. 34)

Figure 36. *Village Scene*. Courtesy of Mrs. Sandra Weiner.

Village Scene (fig. 36)

This childlike rural view Wiener enlarged from a magazine snapshot. In spite of its American origin, its subject matter shows a definite East European flavor. The churches reflect the Byzantine influence of the Russian Orthodox churches and the doors of the small cottages appear to be decorated with the inlay Rumanian peasants carve on the entrances and windows of their homes in order to bring good fortune.[26]

Its charm lies in the fact that it is a study in contrasts. It exhibits the groping of the child in the drawing of the posts and telephone poles referred to in chapter three (figs. 5 and 6), and the skill of an adult in its feeling for the harmonious relationship between areas of color. It also includes the characteristics of the folk painter and the aesthetic qualities of the trained contemporary artist. These traits become more obvious when using an analogy of folk speech and the contrasting polished vocabulary of the educated, professional man. Flopped-over telephone, fence, and telegraph poles are like folk speech, "with its workmanlike, heavy simplicity, emphasis by grimace and gesture, and the repetition of proverbs and old sayings."[27] On the other hand, the space division of the composition, as well as the geometrical shapes of the buildings, triangle, half-circle, pointed spire, round bell tower, are like the precise and calculated structured sentences used by the intellectual or professionally trained.

Figure 37. *Four Birds in a Garden*. Courtesy of Mrs. Sandra Weiner. Photograph by New York State Historical Association.

Four Birds in a Garden (fig. 37)

The incongruity of these brightly decorated birds as they emerge from a somewhat unreal world for a bit of friendly conversation creates a humorous atmosphere in this painting. They immediately bring to mind the folk tale of the Barza which generations of Rumanians have used to explain to children the story of their origins.[28] But it matters little whether the artist recalled these finely textured birds from the folk traditions of Rumania or from the Bronx Zoo. Their merit lies in the quality of design Wiener has unconsciously achieved in relating them to the rest of the painting. The spaces between the two birds, and the trees and the birds, are aesthetically satisfying. Particularly noteworthy is the triangle which is formed by two trees on the side of the birds and the clump of trees in the center of the painting. Then, too, the placement of a minute dotted line of shrubbery on the horizon forces the eye to focus on the center of interest. Finally, the exquisite design of the plants in front cannot be overlooked. Regardless of the human quality which is also obvious in these birds, the lack of perspective which makes the birds the same size as the trees, for example, introduces another dimension to the painting. It is somewhat similar to the atmosphere which Bihalji-Merin describes in the work of Eugene Buktenica: "In his two-dimensional pictures, the childlike lack of perspective makes people and things appear as symbols of inner experience."[29]

Church in the Valley (plate 4)

In spite of this painting's Hudson River School atmosphere, Wiener definitely recalls the quaint scene from his homeland. "I remember this from the old country . . . and the river going by . . . the bridge."[30] The color in this work is outstanding, especially the rich lavender in the tree at the left. The red, blue, and yellow accents on the right, colors of the Rumanian flag, strengthen the European character of the work.[31] The composition of the buildings and the gradual ascension of the pointed evergreens in the background enhance the overall painting. Although Bihalji-Merin was actually describing a painting by the naive painter Miroslav Jovanović, he might as well have been thinking of Pop Wiener's *Church in the Valley* when he wrote:

An attractive peasant house nestles beneath the bridge. All of life surveyed in the highly colored picture has been captured and defined on a single plane.[32]

The fact that Wiener, too, has caught all of life in one plane did not keep him from including those personal images which give his work its native charm. Children jumping rope (fig. 38), small boys fishing off the top of a bridge (fig. 39), are all a part of the memories the artist shares through his paints.

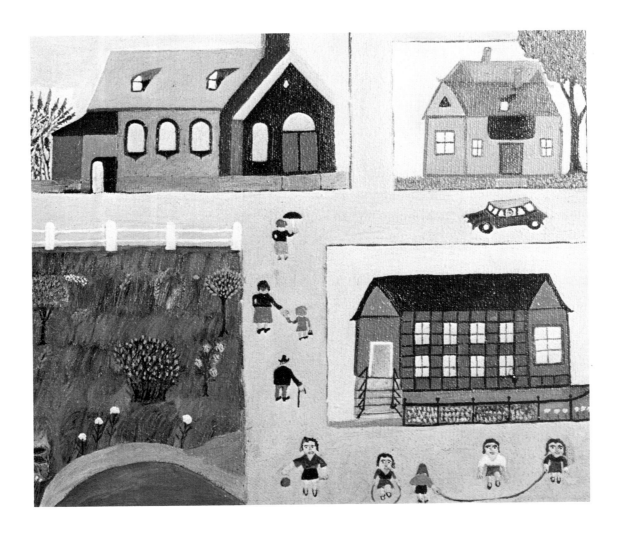

Figure 38. Detail of children from *Church in the Valley* (plate 4)

Figure 39. Detail of boys fishing from *Church in the Valley* (plate 4)

Mountain Scene (plate 5)

This fresh and lively mountain painting captures the *joie de vivre* so characteristic of Wiener himself. The rich colors of the mountain juxtaposed against the joyful and happy color of the foreground activity, cannot help but echo Bihalji-Merin's statement about the paintings of the French naive artist Bombois.

"The painter endows all objects with some of the exuberant strength of his own vitality; landscapes and people possess their own plastic existence and a strong will to live."[33]

The artist has combined two worlds in this painting. The pleasure and fun of the American picnic is presented against a background of Rumanian hills, integrating pictorially the American dream and the Rumanian *Miorița*. These mighty mountains speak to us of another world and visually relate memories of which Pop himself spoke.

Mountains were beautiful, beautiful. . . all kinds of colors. We lived in Durleshty, in the village we lived, like from here, oh, I would say, about five miles there was a mountain, all mountains. . . all colors, and they used to come there, the Russians used to come out, Monarousti, we called them. They come out in the summer time, they plant watermelons, cucumbers, that's their business, honey dews, on the mountains, they used to plant. They raise the land for the summer and they plant it and they put up tents and they live there all summer. . . beautiful. . . and they come just for the summer.[34]

The half-tone sun in the upper right-hand corner of this painting is another motif, like the mountain ranges, which the artist

73

Figure 40. Detail of a small boat from *Four Cows and a Bull* (plate 6)

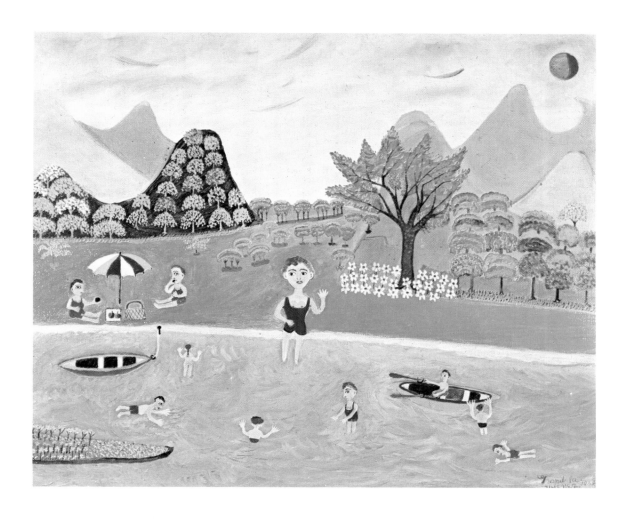

Plate 5. *Mountain Scene*. Courtesy of Mrs. Sandra Weiner. Photograph by Bradley Smith.

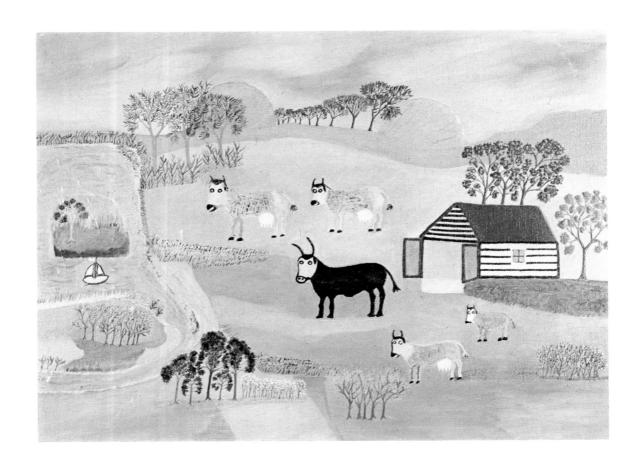

Plate 6. *Four Cows and a Bull*. Courtesy of Mrs. Sandra Weiner. Photograph by Bradley Smith.

often repeats. When asked why he painted this in two distinct tones, one half a deep red-orange and the other a lighter shade, Pop replied:

You see, when the sun started going away, . . . it start getting dark, dark, one side gets red, the other gets light. . . . You watch when the sun comes out, and the sun start going away. There's always half is light, half is dark red. The sun hasn't got one color. Sometime the sun shows red like fire, do you notice that?[35]

Four Cows and a Bull (plate 6)

He paints the smells and colors of the fresh earth. The green of his palette resembles the meadow of his village on which bleached white linen gleams. With an easy idealization and a sure feeling for the decorative, he portrays the unchanging life of the peasant. . . .[36]

Bihalji-Merin made this statement about a painting by the Yugoslavian Martin Palŭskas, but it is also a fitting description of Wiener's vigorous and exquisitely colored farm scene. The huge milk-filled udders of the four plump cows remind one of the memory Pop had as a boy in the old country, as he watched the children of the village waiting for a glass of milk as it came fresh from the cows. Wiener obtained the atmosphere of the scene by using varied and subtle color. The transition of greens into three slightly different shades, from the bottom of the hill to the top, contributes to the vividness of the color. The colorful elements of surprise, however, like the red roof of the barn and the golden humps of the hay, are introduced where least expected, and give the painting its sparkle. Then too, the small boat pictured in figure 40 is an unexpected note which adds a charming touch to the entire composition, while at the same time emphasizing the artist's love of and attention to detail.

Figure 41. *Pastoral Scene*. Courtesy of Mrs. Sandra Weiner. Photograph by New York State Historical Association.

Pastoral scene (fig. 41)

Nowhere is the influence of the Mioritic philosophy more evident in the subject matter of Wiener's work than in this picture of a little Rumanian shepherd and his flock of white fleecy sheep. One of the artist's earliest water colors, its subtle fusion of colors, delicate patterning of lamb's feet, and melancholy atmosphere all contribute to the expression of the intense relationship which exists between the Rumanian folk soul and his horizon. Surrounded by the shelter of the slumbering hills, Mioritic space, the shepherd frequently played tunes which echoed the atmosphere of the valleys and the majesty of the mountains. The following excerpt is taken from the Rumanian ballad *Miorița*,[37] in which a lamb tells his master that two other shepherds plan to murder him. The shepherd's reply to the lamb symbolizes his optimistic view of death and its relationship to nature. It also sheds light on a part of the spiritual ambiance to which Wiener was exposed during his formative years, and the influence it undoubtedly had on this painting.

> "Oh my master dear,
> Drive the flock out near
> That field, dark to view,
> Where the grass grows new,
> Where there's shade for you
> Master, master dear,
> Call a large hound near,
> A fierce one and fearless,
> Strong, loyal and peerless.
> The Ungurean
> And the Vrancean
> When the daylight's through
> Mean to murder you."

Figure 42. Detail of bushes from *Horse and Cart* (plate 7)

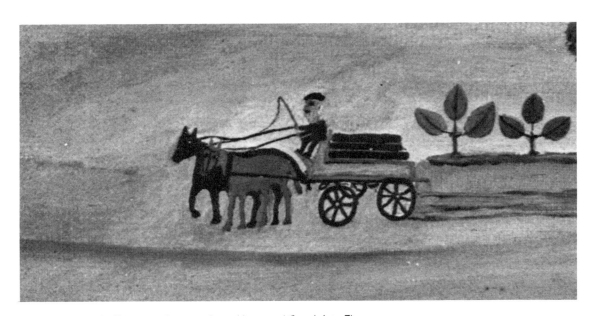

Figure 43. Detail of horse and wagon from *Horse and Cart* (plate 7)

"Lamb my little ewe,
If this omen's true,
If I'm doomed to death
On this tract of heath,
Tell the Vrancean
And Ungurean
To let my bones lie
Somewhere here close by,
By the sheepfold here
So my flocks are here,
Back of my hut's grounds
So I'll hear my hounds.
Tell them what I saw:
There, beside me lay
One small pipe of beech
With its soft, sweet speech,
One small pipe of bone
With its loving tone,
One of elderwood,
Fiery-tongued and good.
Then the winds that blow
Would play on them so
All my listening sheep
Would draw near and weep."

Horse and Cart (plate 7)

Pop Wiener once humorously commented, "I was born between trees."[38] This statement is quite understandable in view of Wiener's empathy with Rumanian *Miorița* and visually verified in the detail of the bushes in the foreground (fig. 42). With meticulous care the artist has painted each detail of the flourishing bushes, trees, and flowers. The horse and wagon (fig. 43) is a motif which Wiener often included in his scenes of his homeland. The mountains, bridge, and stream have likewise appeared in previous works. It is the manner in which he has combined these motifs, however, which makes this such an excellent painting. The repetition of the painted evergreens and the painted leaves of the plant beneath, the variation in the pastels of the bushes, and the balance of the composition, all would lead one to believe that this picture had been painted by a trained artist.

The Witch in the Woods (fig. 44)

Pop explained this unique memory in the following way:

> *This is the crow and this is the witch . . .*
> *she lives in the woods, got a little house in the*
> *woods, the witch. Then the kids, they went*
> *there, in the woods and she comes out and . . .*
> *scares them. The witch is always with a crow.*
> *You know, we used to read stories about a*
> *witch, the crow, I can't remember, it was so*
> *many years . . . don't forget, I'm not a young-*
> *ster no more. The kids, like, go out in the woods*
> *in the summer time, so they got to a point*
> *where they saw a witch, scared them off . . .*
> *I know, I must have read it.*[39]

Figure 44. *The Witch in the Woods*. Reproduced through courtesy of the New York State Historical Association.

The Witch in the Woods, painted in 1966, is of special interest not only because of its instinctive sense of color, linear tree patterns, and obvious references to Rumanian folk culture, but also because it is one of the few paintings which the artist made displaying an element of fear.

The emotion is heightened by the introduction of the crow motif. According to Israil Bercovici, crows are often seen in Rumania and are frequently the source of an old folk curse. In an interview he said, "The crow is a curse; if you curse a man you say, 'May a crow eat his heart.'"[40] This bird has also been a traditionally ominous image in Rumanian folk art. The crow in *Winter in Mahala* by Ion Ţuculescu, a contemporary Rumanian painter who strove to revitalize the folklore of his country, bears a striking resemblance to the crow which hovers over the witch and intimates, like the bird in *Witch in the Woods*, a sense of imminent disaster.

Even though Wiener has used happy colors in this work they do not compensate for the element of fear so evident in the wide-eyed countenances and large expressive hands of the children. Figure 45, a close-up of the witch, arrayed in Rumanian costume,[41] is again indicative of the suspense prevalent in this work.

One might see this as a memory of the ghost stories the boys in the *heder* told when the teacher went to say his evening prayers,[42] or an unconscious symbol of the fears the young Wiener faced during the time of the pogroms. Yet the bright color and the control of the brush reveal that, although this may be a fear retained from childhood, it no longer has the meaning for the adult it once had for the boy.

Figure 45. Detail of witch from *The Witch in the Woods* (fig. 44)

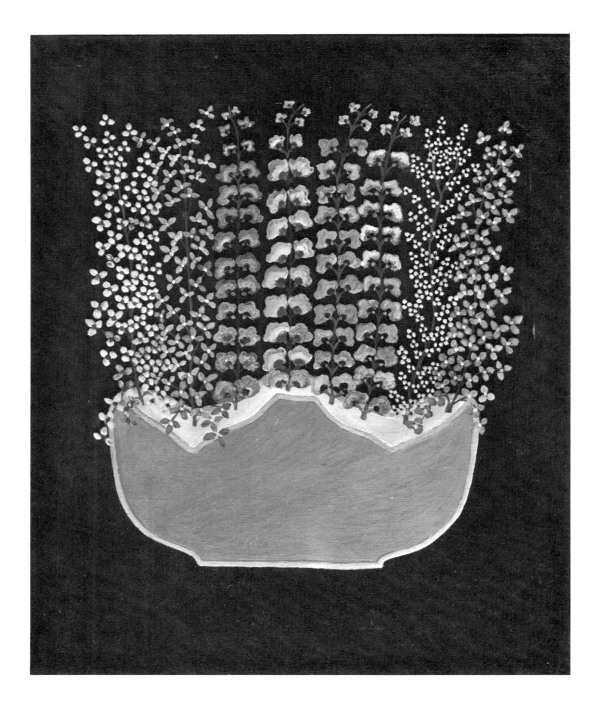

Figure 46. *Orange Bowl of Flowers*. Courtesy of Mrs. Sandra Weiner. Photograph by New York State Historical Association.

Orange Bowl of Flowers (fig. 46)

This exquisitely designed orange bowl of blossoms painted against a stark maroon background appears to be filled with little yellow mulleins and flowers from the dwarf almond tree.[43] The flowers, colors, and patterns reflect the character of the artist as well as the Rumanian folk art tradition he had been exposed to as a boy.

There is a striking similarity between Wiener's bowl of flowers and *Still Life* (fig. 47) by Ion Niţă Nicodim, a naive peasant artist now painting in Rumania. It has been said of Nicodim's work that "it sings of nature and fruit bearing life in unlimited joy."[44] This statement also describes Pop's *Orange Bowl of Flowers*. Both artists have been influenced by Rumanian *Mioriţa*. Like Ion Ţuculescu, also of the Rumanian painting school, they have continued the Rumanian flower-painting tradition of the past and have, in the words of Comarnescu, "individualized almost every flower, revealing its distinctive form and color, vibrating [it] with a life that the artist instinctively divined."[45]

To the trained artist, a still life like *Orange Bowl of Flowers* may be nothing more than an exercise. To Pop Wiener, painting this picture was an experience through which he expressed what he had seen and felt throughout his life.

Figure 47. *Still Life*, by Ion Niţă Nicodim. Reproduced, by permission of the Rumanian Library, New York City, from the film *Anotoimpur si Culori*.

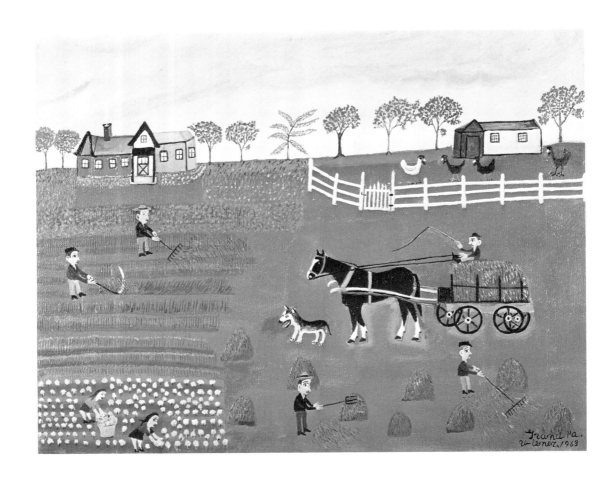

Figure 48. *Harvesting*. Courtesy of Mrs. Judith Stanton. Photograph by Bradley Smith.

Harvesting (fig. 48)

In *Harvesting* the integration of aesthetic and cultural influences which makes the art of naive painting so unique and valuable is obvious. Wiener has treated the space in a classical manner and used rich harvest gold color to heighten the effect. The spatial arrangement, as well as the flattened cubist perspective in the Rumanian farmhouse in the upper left corner, tends to focus attention on the military posture of the farm workers, who seem to have been eternally barred from completing their farm chores. The farmers use hay rakes and scythes, without cradles, to accomplish their tasks. The primitive tools, the architecture, and the whip which the driver vigorously swings as he sits atop the horse-drawn cart all afford the viewer a glimpse of old-world farm life.

Apparently Pop could not resist inserting a particularly Jewish element into the work. The women are picking large baskets of rich cabbage, which was a stock vegetable in the gardens of Jews in eastern Europe. Moses Rischin, an authority on the Jews of the period, commented on the produce which might be found in the Jewish shtetl gardens in his book *The Promised City*. He stated, "Jews cultivated their own gardens, they raised the 'Jewish fruits,' beets, carrots, cabbage, onions, cucumbers, garlic and horse radish."[46]

In the midst of this painting's ostensibly European atmosphere, the contemporary dress, especially the short skirts of the women, cannot be overlooked. It would appear that Wiener deliberately included an intimate image in order to assure the viewer that this is the painting of an American artist, although his origins were European. The inclusion of the horse and dog motifs, symbolic of man's youth and old age,[47] further confirms the assimilation inherent in the painting. Each textural section of the painting, as well as each object painted, has its own value, but also forms an integral part of the whole. Like the artist who painted it, *Harvesting* reflects the acculturation which took place in the life of the American Jew, while at the same time, it sheds light upon the nature of the naive painter.

Odessan Still Life (fig. 49)

"This was brought from Europe, my mother-in-law . . . she brought it from Odessa. I made a painting . . . it's porcelain."[48] Pop's description of the Odessan bowl is brief but significant. The rich red and white apples and cherries placed against a varied blue background are about to burst forth from their compact container—like the fruits and flowers of the old country, which so often crop up in the memory paintings of Wiener. He gave the still life an interesting two-dimensional—three-dimensional form which unconsciously crept into a painting motivated by the feelings and cherished images that the vessel inspired.

Figure 49. *Odessan Still Life*. Courtesy of Mrs. Sandra Weiner. Photograph by New York State Historical Association.

Life In The United States

Wiener's later paintings were more often inspired by places, objects, people, and events with which Pop came in contact in the United States since the time of his arrival in 1903. Like his early paintings, they reflect the life and character of the man who created them.

The Falcon (fig. 50)

Of the bulbous-eyed fellow who sits proudly perched on a miniature tree, Pop remarked, "I always like to paint those falcons. I like those birds, so I paint 'em, I like to paint birds, animals."[49] It is possible that the distortion of this monstrous bird perched on the branch of an undersized tree had its inspiration in something beyond Wiener's inability to paint perspective or his love of animals. It may be, in fact, that Wiener is unconsciously recalling a Jewish folk tale like the "Demon in the Tree," which he could have heard in the old country. This tale and others like it were based upon the belief that demons endowed with superhuman powers inhabited trees.[50] The mosaic-like flower, the beautifully painted tree, the careful work of the birds' feathers, all show the attention to detail which is so characteristic of Wiener. He is not alone in this, however, for Louis Viven, a French naive painter who lived before Wiener, "hated the summary, the generalized. He felt that nothing must be lost when we take inventory of reality, and this discursiveness was an essential character of his art."[51]

Rawhide (fig. 51)

This superbly designed cattle-drive had its source in the great American invention, the television western. It still has several old-world motifs like the mountains and the horse and wagon which Wiener nonetheless included in the painting from his boyhood memories. The detail of one of the cattle-drivers (fig. 52) shows that the man who painted this picture knew how to handle a whip and how a harness fitted correctly on a horse. As Pop said, "I used to whip, myself, when I was in the old country. . . . We, I had a horse and wagon, I used to travel, I used the whip, giddy up."[52] The hesitancy of the cattle before going into the water, similarly reveals an understanding on the part of the artist of animal ways. Although the following quotation was written in reference to the work of Bombois, it applies very well to the painting *Rawhide*:

There is nothing which has not been inwardly experienced, solidly felt. He invents nothing, he distorts nothing on the pretext of artistic interpretation. He is neither an intellectual nor a priest, he is a man of the people whose conception of the world derives from what he has learned through his muscles and his nerves.[53]

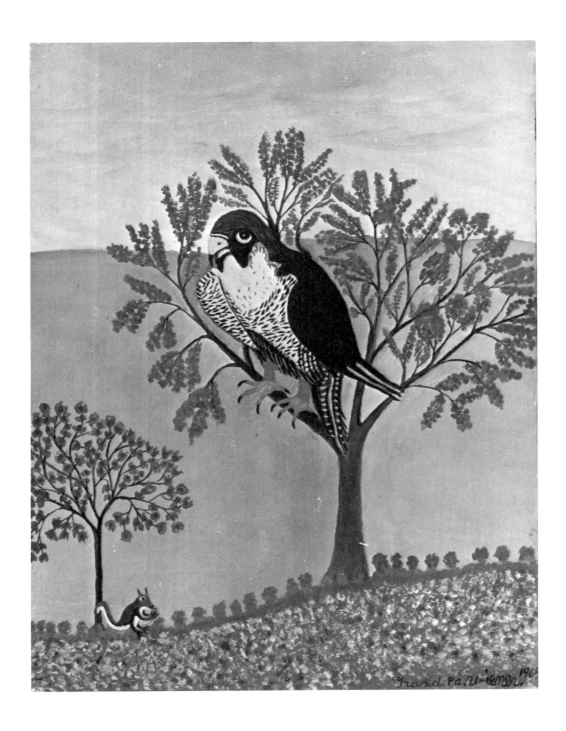

Figure 50. *The Falcon*. Reproduced through courtesy of the New York State Historical Association.

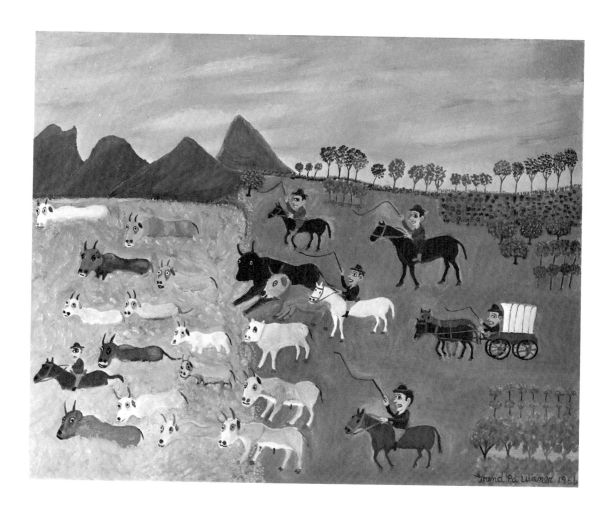

Figure 51. *Rawhide*. Courtesy of Mrs. Sandra Weiner. Photograph by New York State Historical Association.

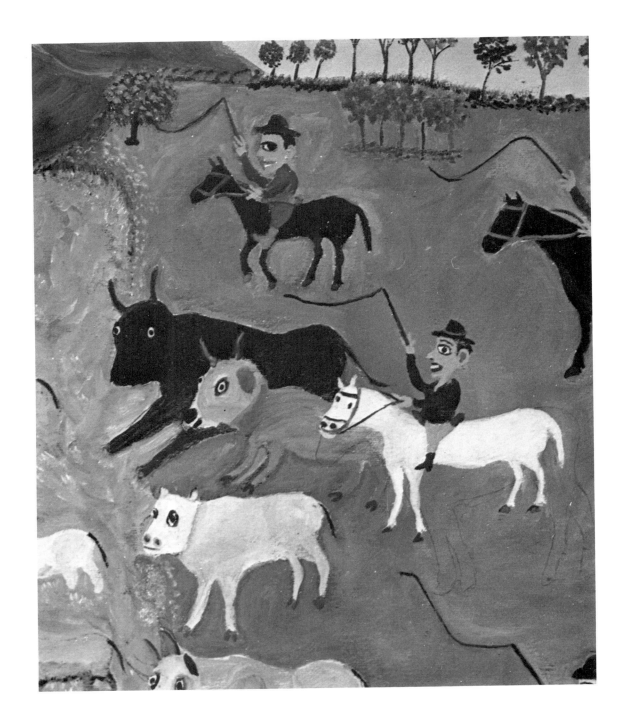

Figure 52. Detail of cattle-driver from *Rawhide* (fig. 51)

Figure 53. *Ginger*. Courtesy of Mrs. Sandra Weiner. Photograph by New York State Historical Association.

Figure 54. Pop and Ginger, about 1960

Ginger (fig. 53)

In this exotic painting, which reflects the harmony between man, animals, and plants characteristic of the Mioritic philosophy, Pop has placed his beloved German shepherd in a setting of felicity and color. This is the interpretation he gave when questioned about the painting:

I had a German shepherd . . . before my wife passed away. He got killed here in the mountains. It was some dog, his name was Ginger. When he got killed, it took my heart away. He was just like a child to me.[54] I trained him, he used to be so smart . . . that dog, you talk to him, he listened. . . . He used to sleep on the porch on the screen, studio couch. My daughter-in-law said, "Why you let, she comes in from outside wet sometimes and she gets the nice couch dirty.' So, I took a piece of rug, I took her in the living room, I say, 'Ginger, you gonna sleep here, no more there, over here you're gonna sleep. Lay down there!' and she never went back on the couch.[55]

The realism of Pop's explanation is not as evident in his treatment of the painting. The abstract quality of the exquisitely patterned garden gives the picture a celestial appearance; it appears to be compassionating with Wiener over the loss of Ginger. The meticulously painted tree to the right of Ginger (fig. 55) reflects this theme. Like the foliage in the paintings of Rousseau,

Objects are painted in meticulous detail, but these trees and flowers do not belong to any known botanical species. . . . His proportions are not those of the visible world; they are integral components of his own vision. The plant life . . . constitutes a decorative, stylized, hitherto unseen landscape of his own invention, monumental in its harmony.[56]

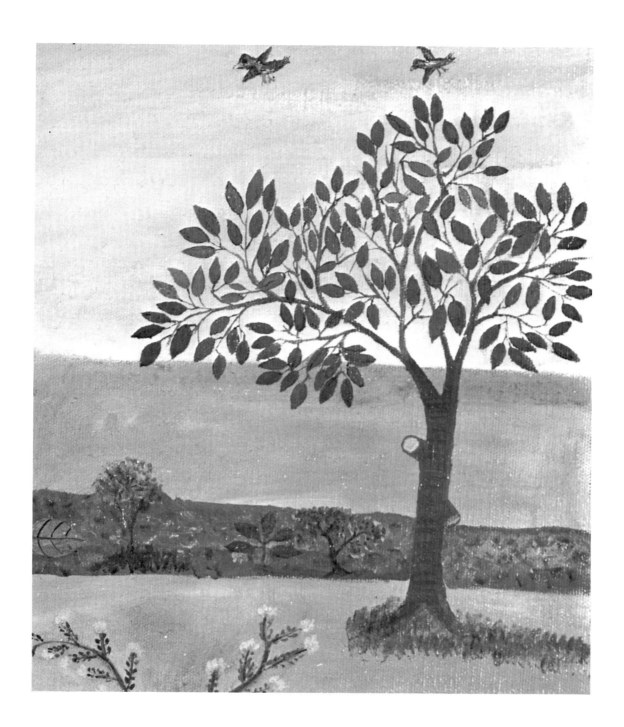

Figure 55. Detail of tree from *Ginger* (fig. 53)

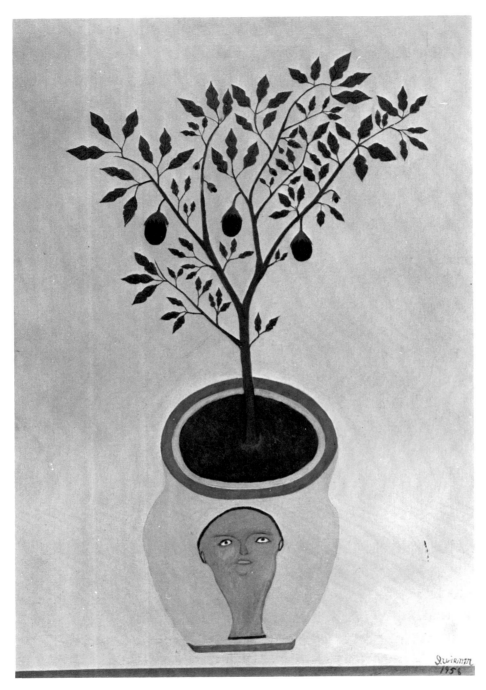

Figure 56. *Eggplant Tree*. Courtesy of Mrs. Sandra Weiner. Photograph by New York State Historical Association.

Eggplant Tree (fig. 56)

The potted plant pictured in this illustration was one of the eggplants Pop raised in Smallwood, New York.[57] Not only are the formation of the plant and the arrangement of its leaves beautifully executed but it also vibrates with a vital and living quality. Wiener is akin to the peasant painter Ivan Generalić who, as Bihalji-Merin put it, "seems to have distilled into his paintings the natural, personally experienced process of ripening and growth, the invisible processes of the plant world."[58] This quotation is still more appropriate in the light of the account of Pop's love of growing things given by a friend in Monticello:

A year ago in September, one day, he came knocking at my door . . . and he had a great big bag of the most beautiful tomatoes you ever saw. . . . I couldn't have been more excited if he had given me a dozen roses, because he'd grown them and he was so proud of them. He's got that, you know, the color, ripeness and fullness and that tender loving care, and this is just a part of it. . . . He seems to have . . . a reverence for living things.[59]

Bar Scene (fig. 57)

The naiveté of Wiener's artistic talent is most obvious in his reply to a question concerning the spacing of this marvelous work. When asked the reason for placing the objects in the bar the way he did, Pop replied, "Well, there's the bar, and there the tables and people . . . and somebody is singing, they are entertainers . . . there's the piano."[60] He was completely unaware of the fact that he had created a contradiction in space much like the type of spatial studies the contemporary artist sets out to do. The placing of the bar and piano, which have depth, against the wall and floor, which have no space, results in an intriguing phenomenon. Then, too, the various points of view which are present to the observer—looking down on the floor, straight ahead, etc.—coupled with the size of the people, make it a major feat to place the figures at a definite eye level. This tends to emphasize the already significant surrealistic character of the painting.

Wiener, in short, has taken a common, everyday occurrence and naively endowed it with a unique artistic character.

John Fitzgerald Kennedy (fig. 58)

The tragic assassination of President Kennedy in 1963 was an event which affected the life of every American. Wiener, likewise, was moved by this incident: he said, "After he [Kennedy] was killed . . . his picture was in the news, so I made a painting."[61] This is the only portrait the artist made. It expresses very well his ability to paint the way he felt about something. Motivated by the emotion he felt at the assassination, Wiener captured Kennedy's unique physical characteristics: the line of the hair, the shape of his eyes, the thrust of the shoulders, and thus created the likeness of a most admired American.

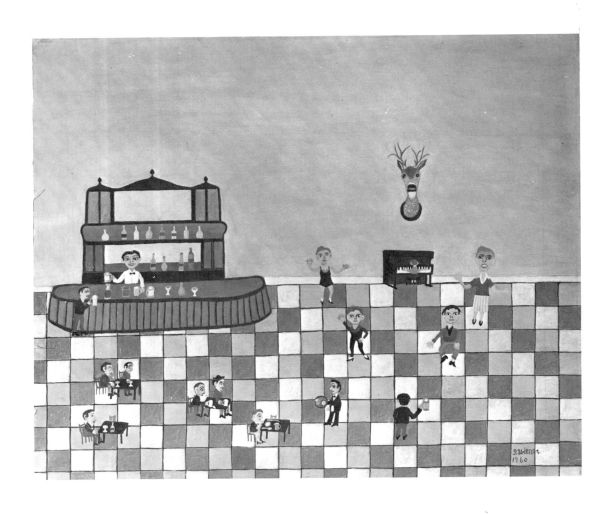

Figure 57. *Bar Scene*. Courtesy of Mrs. Sandra Weiner. Photograph by New York State Historical Association.

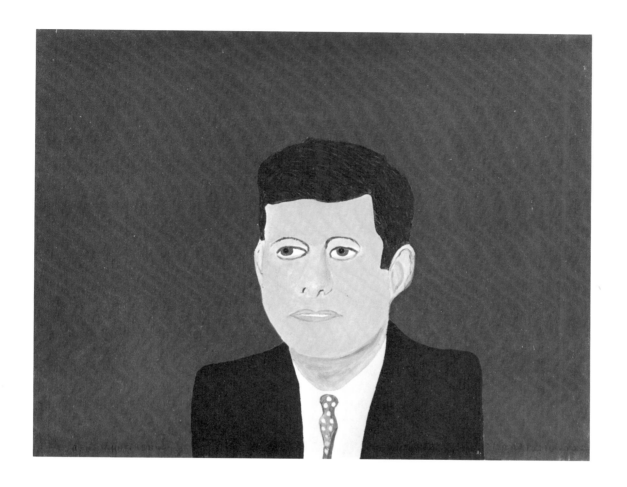

Figure 58. *John Fitzgerald Kennedy*. Courtesy of Mrs. Sandra Weiner. Photograph by New York State Historical Association.

Figure 59. *Knickerbocker Village*. Courtesy of Mrs. Sandra Weiner. Photograph by New York State Historical Association.

Knickerbocker Village (fig. 59)

Just as Pop painted a single portrait, he produced only one view of a city. He recalled having seen this village in New York, many years ago.

It's . . . on the East Side, 23rd Street . . . there's a project there with a lot of houses, Knickerbocker Village, Knickerbocker Village . . . a lot of houses, big buildings like this here [this painting], all 'round . . . up 3rd Avenue. . . . I saw that project, it's right up the Brooklyn Bridge, on the left side of the Brooklyn Bridge.[62]

Wiener has once again handled the space in a most intriguing manner. The point of view forces the viewer to look down onto the pattern of black roofs. The shapes, subtle colors, and design combine to make this one of the artist's most exciting paintings. When asked why he did not repeat this theme, Pop replied: "I wasn't interested."[63] However it seems more likely that Wiener really meant that he had said all there was to say about Knickerbocker Village. He captured this New York scene with verbal and aesthetic simplicity.

Copy of Monet (fig. 60)

Wiener saw a picture of Monet's *Terrace at Sainte Adresse* (fig. 61) and was amazed at the amount a museum paid to purchase it. The result was this gay, lively *Copy of Monet*. Although this is a copy, Wiener had definite feelings about copying another artist's work. He said, "If I copy the same thing, it's no good. . . . Why should I make a painting that somebody else made?"[64] He was much like a fellow Jewish naive painter, Morris Hirshfield, in this regard. Janis's analysis of Hirshfield's work could also be applied to Wiener's *Copy of Monet*: "He has taken possession of any borrowings as a creative artist always does, by incorporating them within his own personality so thoroughly that they become an integral part of his own expression."[65]

It is in the detail of the abstract flower patterns to the left of the terrace (fig. 62) that the real ingenuity of the artist is apparent. Wiener has translated Monet's landscape into a floral fantasy-land. Like the work of Ondrej Venjarski, Wiener's flowers "reflect more imagination, poetry and a greater power of observation. . . . There is an archaically childlike, abstractly generalized quality to the picture, which lends to its curious charm."[66]

The lower right side of the painting is also significant. The right-hand corner displays an overlapping of colors and shapes. The orange-backed chairs, in relation to the chartreuse lawn, delicate lavender umbrella, and pointillistic flowers beneath create an excellent composition. The form of the chairs in relation to the patio also fits into this scheme with facility.

Pop thus combined his own instinctive sense of design and color with a familiar subject to create a painting which is as original as it is pleasing.

Figure 60. *Copy of Monet: Terrace at Sainte Adresse.* Courtesy of Mrs. Sandra Weiner. Photograph by New York State Historical Association.

Figure 61. *Terrace at Sainte Adresse*, by Claude Monet. Courtesy of the Metropolitan Museum of Art. Purchased with special contributions and purchase funds given or bequeathed by friends of the Museum, 1967.

Figure 62. Detail of flowers from *Copy of Monet* (fig. 60)

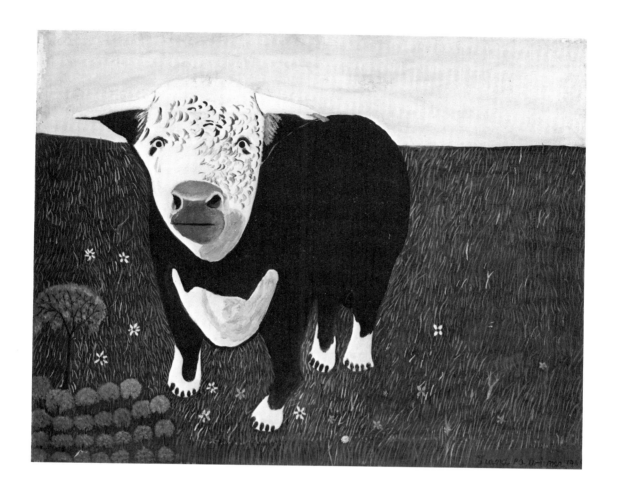

Figure 63. *The Bull*. Courtesy of Mrs. Sandra Weiner. Photograph by New York State Historical Association.

Figure 64. Photograph of bull from *Life* magazine, by Dimitri Kessel. Reprinted, by permission, from *Life*. © 1972 by Time Inc.

The Bull (fig. 63)

While looking through *Life* magazine Wiener became impressed with the photograph of a bull which had been bought for a high price at a cattle auction (fig. 64). Perhaps it brought back memories of the days in the country when a poor Jew's dream of happiness was to become the owner of a bull which would enable him to feed his family,[67] or perhaps it symbolized his own struggle in life to support his wife and son Danny.

Wiener did not state underlying reasons for painting his lovable bull, which in fact does not at all resemble the magazine photograph. The human expression, the terrier paws (which the artist used because they were the only paw image he had stored in his imagination), the miniature trees, once again confirm that "the realism of the primitive painter is not that of a portrait. Even when his work is based on a photographic model, his realism is that of memories, dreams and symbols."[68]

The power of the animal is emphasized by his head-on position and the fact that the field has no depth. It almost appears as if the bull were being pushed out at the viewer from the flat canvas. The conviction and sincerity with which all these elements are combined, make this painting a naive painter's masterpiece.

Political Panorama (fig. 65)

This painting, made by the artist in 1960, can best be described as paradoxical. These winged creatures appear like hybrid mythological beasts, or some fearful image hidden in the artist's imagination. The viewer is free to read into this triangular-shaped panorama any explanation he wishes. The artist's interpretation revealed, without a doubt, that he meant this to be a humorous, political painting:

When Nixon got elected as vice-president, I put in Nixon, Krushchev, one is a pig, one is a bird, Krushchev's the pig, no the chicken. . . . They are all politicians. . . . The lion is Nixon. I didn't like him because he looked always mad.[69]

When asked why he put a monkey's face on a bird's body, Pop replied, "Otherwise, it wouldn't be fun . . . chicken feet, chicken legs . . . I don't remember."[70]

Greek Revival in Hartford (plate 8)

It was in Hartford, Connecticut, they have a rose garden there, it must have been something I've seen years ago. One of my friends took me to Hartford, years ago, I think [it] was during the World War. There's a park there, a wonderful park. I remembered that, and I painted it.[71]

This was Wiener's brief account of a magnificent flower-land he remembered from Elizabeth Park in Hartford, Connecticut (fig. 66). The interaction of the forms and colors of the decorative flower motifs make an extremely fresh and vigorous painting. The little figures in the front of the Greek Revival building add a personal touch to the picture; in fact the face of the woman has the same round face as his wife, as a comparison with her photograph (fig. 4) reveals. There is a happiness in this painting which is achieved through the use of bright, joyful colors and a warm, friendly subject matter. When asked about the relationship of the couple in the painting, Pop answered, "I don't know if they were married or not."[72] His answer was humorous enough to dispel any further questioning on a subject which brought back too many memories of happy days which had long since passed.

Figure 65. *Political Panorama*. Courtesy of Mrs. Sandra Weiner. Photograph by Bradley Smith.

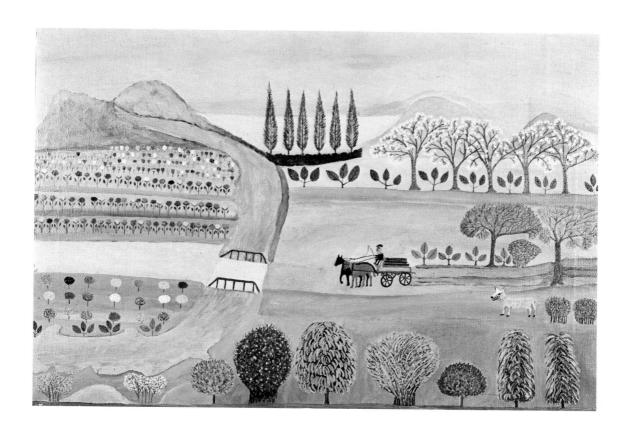

Plate 7. *Horse and Cart*. Courtesy of Mrs. Sandra Weiner. Photograph by Bradley Smith.

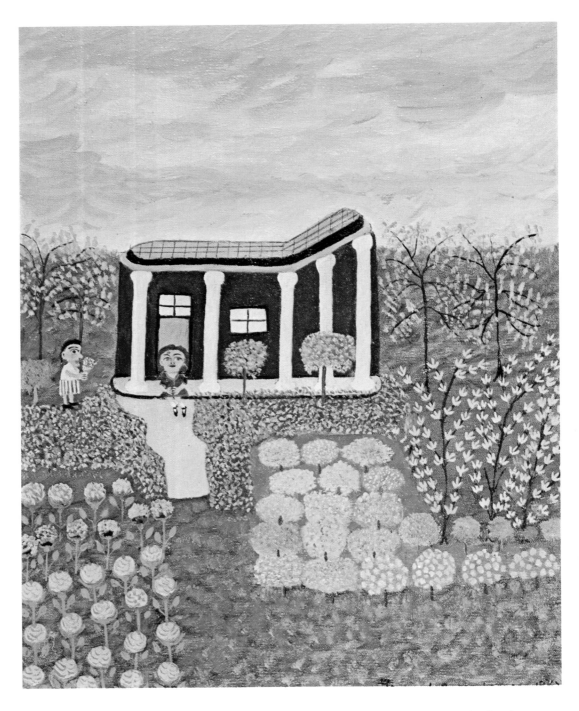

Plate 8. *Greek Revival in Hartford*. Courtesy of Mrs. Sandra Weiner. Photograph by Bradley Smith.

Figure 66. Elizabeth Park, Hartford, Connecticut, about 1917. Courtesy of the Bronson Collection, New Haven Colony Historical Society, New Haven, Connecticut.

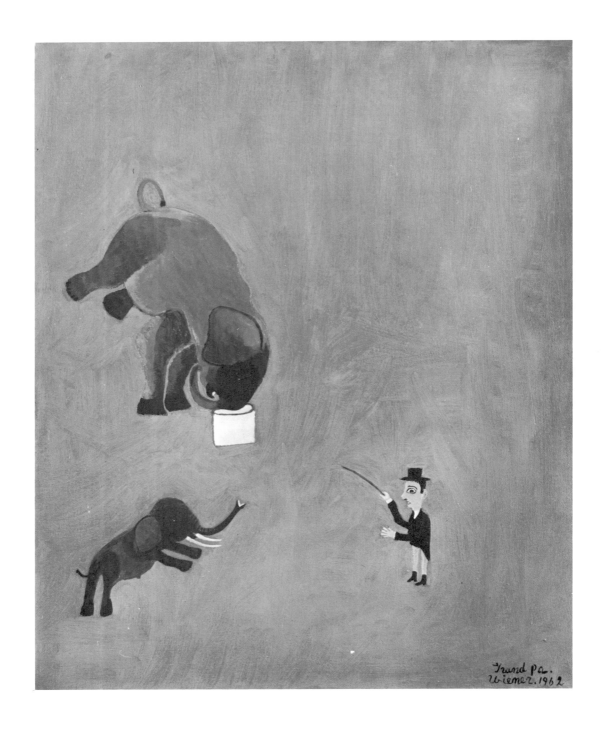

Figure 67. *The Circus*. Courtesy of Mrs. Sandra Weiner. Photograph by New York State Historical Association.

The Circus (fig. 67)

There is a festive quality to this bright orange circus scene. Again, Pop chose an appealing picture from the newspaper and endowed it with a typically Wieneresque naive splendor. This is particularly true of the surrealistic treatment of the space. The figures are unrelated except by the large orange space. The viewer can readily see that the little man is directing the elephants, yet they dance and play in mid-air. How unconsciously clever Wiener has been. There is a striking resemblance between this painting and the elephant in the painting by the French naive painter Sabine entitled *Antoine regarde pour la première fois un Éléphant*. It is remarkable that cultural influences, circumstances, and miles separated these two artists. Nevertheless, they have both been fascinated by the huge elephant and minute man's relationship to him.

Bathing and Boating Scene (fig. 68)

This seaside view likewise expresses Wiener's exuberance and delight in living. Fishing, swimming, boating, and picnicking are but a few of the playful activities the artist included in this day of fun. How masterfully he has balanced the row of boats on the horizon so that the viewers' attention must focus on the picnicking. How skillfully he has depicted the flowers surrounding the little girl snuggled under the umbrella (fig. 69). Yet the most meaningful and pleasing aspect of the entire painting is the human quality it possesses. This is especially apparent in the detail of the little girl in the bathing suit (fig. 70) waving to the viewer. The child establishes an immediate rapport with the viewer and gives this painting "an easily comprehended human quality that may be shared by everyone."[73]

Wiener was not alone in his choice of this subject matter. There is a marked similarity between Wiener's *Bathing and Boating Scene* and Helena Adamoff's *Les Pêcheurs*. The happiness and joy of leisure moments shared with friends obviously pleased them both.

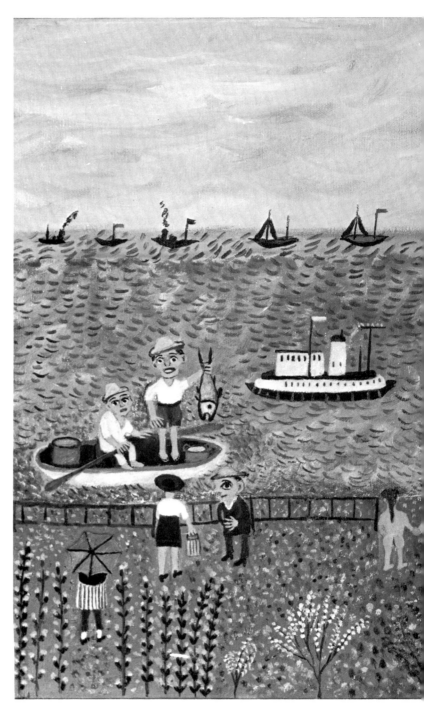

Figure 68. *Bathing and Boating Scene.* Courtesy of Mrs. Sandra Weiner. Photograph by New York State Historical Association.

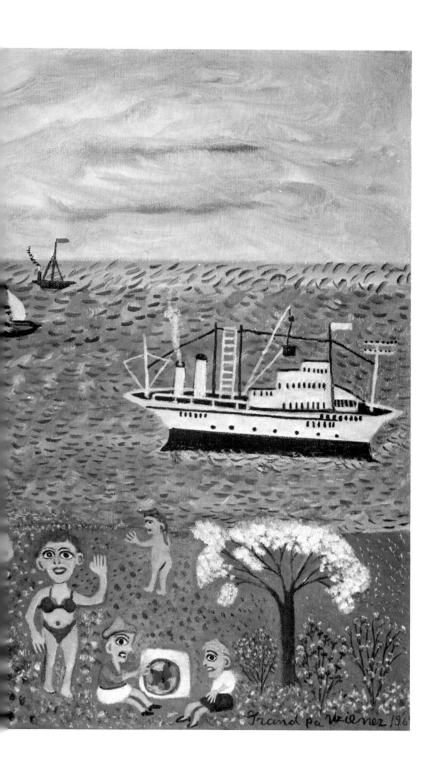

Grand pa wiener 196

Figure 69. Detail of flowers from *Bathing and Boating Scene* (fig. 68)

Figure 70. Detail of little girl from *Bathing and Boating Scene* (fig. 68)

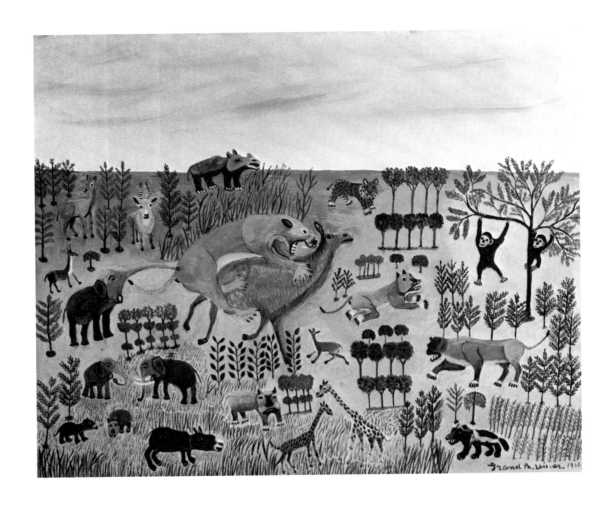

Figure 71. *Jungle Scene*. Courtesy of Mrs. Sandra Weiner. Photograph by Bradley Smith.

Jungle Scene (fig. 71)

This is one of several jungle scenes Wiener painted, and was inspired by the movies. In this picture he parallelled the work of the naive artist Bombois who "communicates some of his own overflowing vitality"[74] into each painting. This is even evident in Pop's description of this menagerie of motions and movement:

See, the lion jumped on the . . . lamb or something. See the elephant, hit him right in the back and see where he opened up his mouth, he got scared. Well, you see he jumped on him and then the elephant was there and bango, he gave him a sock in the back.[75]

The decorative play of light and dark in the trees is exquisitely patterned. The color is bright, gay, and happy, in spite of the struggle between the lion and the lamb. There is a strong resemblance once again between Wiener's jungle scene and two other naive painters' works, *The Jungle; Tiger Attacking A Buffalo, 1908* (fig. 72) by Henri Rousseau and *Le Royaume des animaux* by Matija Skurjeni. The former portrays an assault by the tiger on another animal similar to that exhibited in the Wiener painting, while the latter has the same patterned display of animals centered around a focal point.

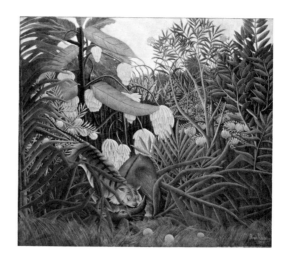

Figure 72. *The Jungle: Tiger Attacking a Buffalo*, by Henri Rousseau. Courtesy of the Cleveland Museum of Art, Gift of Hanna Fund.

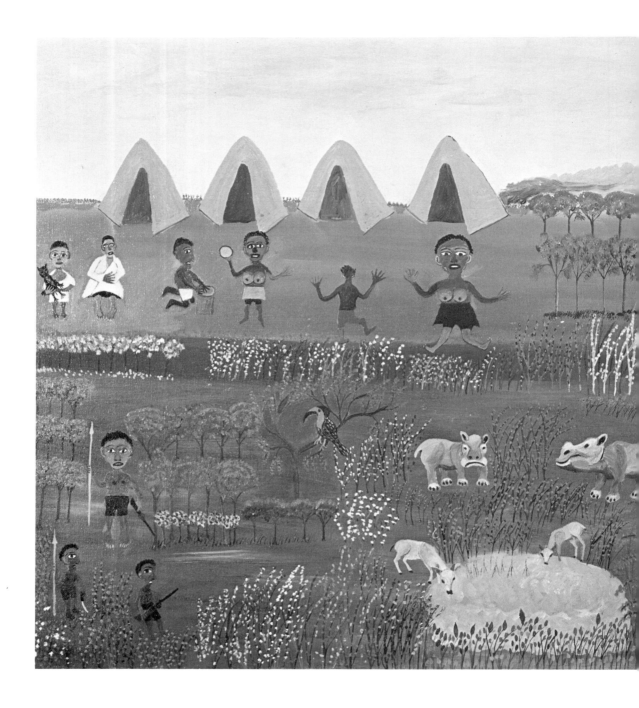

Figure 73. *The Jungle*. Courtesy of Bradley Smith. Photograph by Bradley Smith.

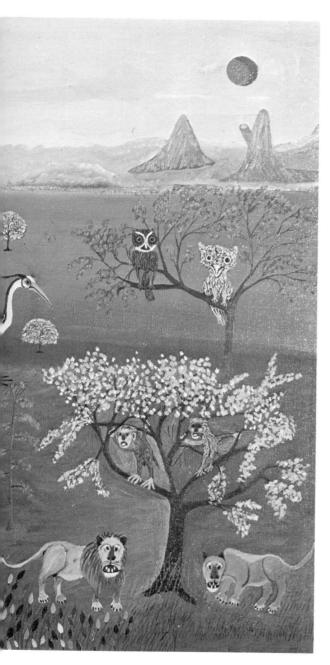

The Jungle (fig. 73)

African jungle life to the tune of Bongos, as wild animals move in opposite directions across the canvas like the syncopated animals on a carousel: this epitomizes Pop's delightful painting *The Jungle*, which had its source in the photographs Pop's son Danny took on a photographic tour to Africa. As Pop commented, "Danny took photographs of how Africans looked, danced, their town."[76]

The painting is full of popular humor and is a source of intrigue when one observes that the artist transformed a photograph into a chronicle of African village life and festivity. African huts huddled on a bright green carpet lawn are the background from which the daily activities of tribal life are enacted. Some pygmies do a ritual dance while others engage in the hunt in the dense thicket of the jungle. Both animals and people display an appealing awkwardness and a stylization which resembles puppets woven in Rumanian carpets or painted on folk pottery.[77]

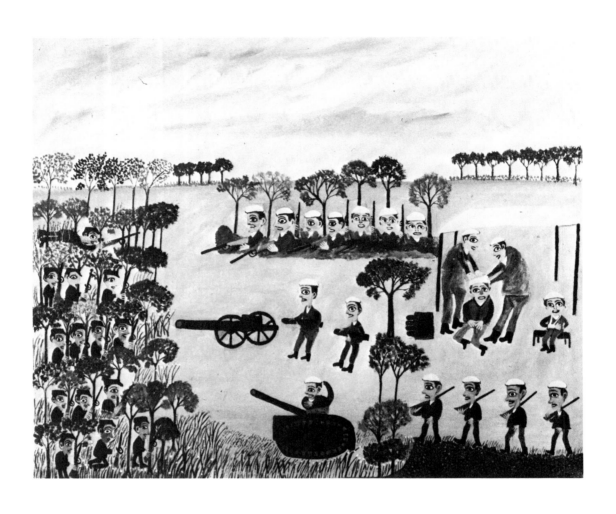

Figure 74. *Korean War Scene I*. Courtesy of Mrs. Sandra Weiner. Photograph by Bradley Smith.

Korean War Scene I (fig. 74)

In spite of the fact that Pop stated "I don't want no war, I'm against it . . . any war . . . wars, what good are they? They destroy families, destroy property, destroy wealth, I have no feelings for that,"[78] he painted several war themes. It is obvious, however, in this battle scene that he did not use the subject matter to express his feelings about war. He has instead employed the battle motif for the purpose of telling a story through line, color, and form. The lower left-hand corner of the painting is noteworthy. Wiener outlines his forms in clear sharp lines; he does not allow them to overlap, thus creating an excellent patterned effect. It is unusual to observe such fascinating color effects when the predominant tone is a neutral khaki.

Man in Boat (fig. 75)

This is another of Wiener's appealing "everyday" scenes. There is a touch of irregularity in the detail of the little man (fig. 76) who is sailing a boat which is smaller than he. This does not serve as a distraction, however, but rather confirms the overall style of the artist, who concentrates more on the happiness and brilliant color this memory evoked than on attaining accurate perspective. It also reveals the artist's appreciation for all the simple joys he experienced in life.

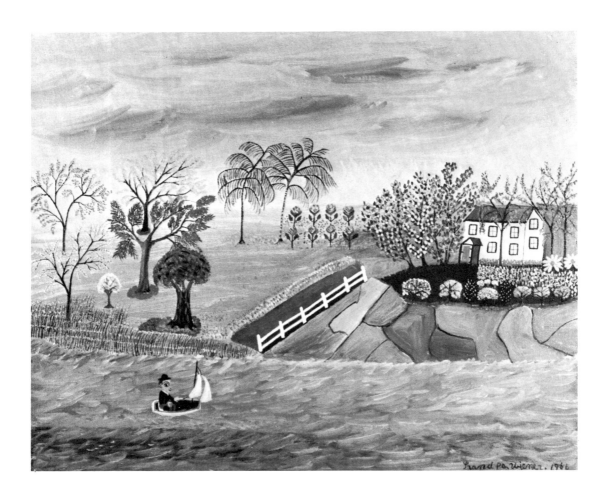

Figure 75. *Man in Boat*. Courtesy of Mrs. Sandra Weiner. Photograph by Bradley Smith.

Figure 76. Detail of man from *Man in Boat* (fig. 75)

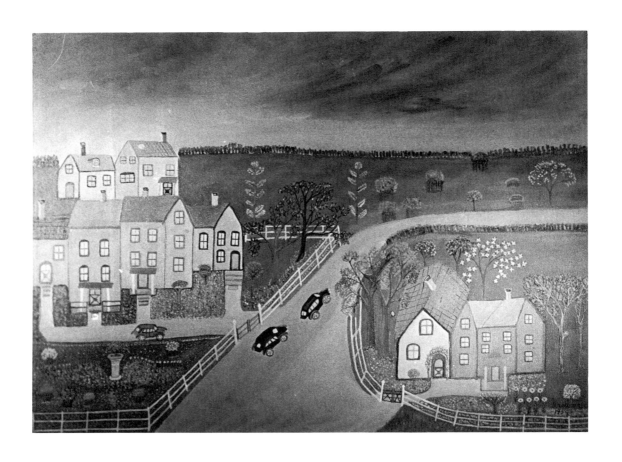

Figure 77. *Two Cars Climbing a Hill*. Courtesy of Mrs. Sandra Weiner.

Two Cars Climbing a Hill (fig. 77)

Pop said, "I think this scene was in Long Island somewhere."[79] It was one of his earliest works, painted in 1959. Again, it is the interlocking of shapes and color which is most pleasing in this painting; the geometrical shapes and color alone would make an excellent composition. The texture of the buildings gives a feeling of stucco, and the idiosyncratic handling of perspective is one of those occurrences in the painting of naive artists which makes it so enjoyable. Pop was attracted by a typically American scene and impregnated it with a simplicity and directness which were also a part of his character.

Street Scene (fig. 78)

In this painting, one of several such street scenes, Wiener's emphasis is on textural patterns, their color, shape and form. With gusto and verve, Pop paints a smooth sidewalk next to the stucco stone patio in front of the church. Not satisfied with the patterns this creates he turns his attention to the brick houses in the upper left-hand corner of the painting. The painting of each brick was done with detailed study in order to emphasize the contrast in texture between their roughness and the delicacy of the billowy flowers surrounding the house. He then strategically placed the stubble-like trees on the grass carpet background, unifying and synthesizing the textural quality of the painting.

It is difficult to classify the painting as to the source of its inspiration. As in so many of his pictures, Pop employs a variety of European and American motifs. One element stands out, however. Pop, with his characteristic warmth and a touch of humor, peoples the scene with characters who are unmistakably Jewish.

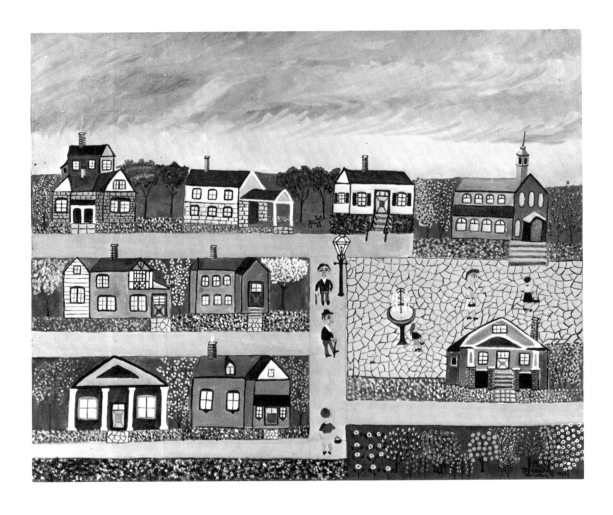

Figure 78. *Street Scene*. Courtesy of Mrs. Sandra Weiner. Photograph by New York State Historical Association.

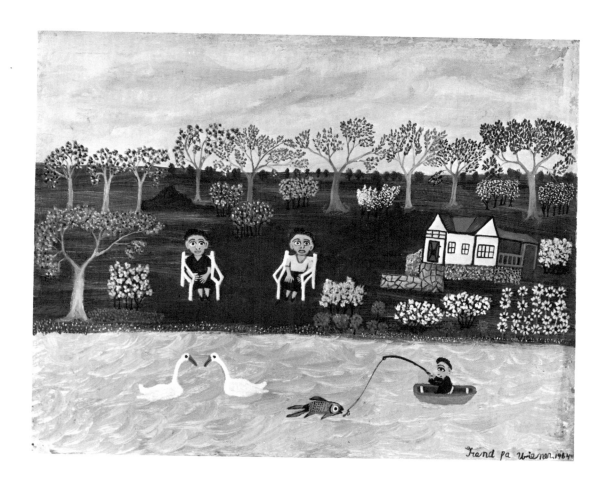

Figure 79. *Lake Quassapaug.* Courtesy of Mrs. Sandra Weiner. Photograph by New York State Historical Association.

Figure 80. Lake Quassapaug, Connecticut, about 1920. Courtesy of the Bronson Collection, New Haven Colony Historical Society, New Haven, Connecticut.

Lake Quassapaug (fig. 79)

This painting was inspired by a summer resort area, Lake Quassapaug in Connecticut, where Wiener and his family used to spend summer holidays in the early 1920s (fig. 80). "There was a lake there, and we used to go swimming there, bathing, they had those little houses . . . trees all around,"[80] Pop recalled. Each of the details, including the individual flowers on the bushes, the Swiss chalet decoration of the cabin, the swans and the boy fishing, gives the painting a secure atmosphere. The unconscious arrangement of cropped shrubs and flowers contributes to the resort theme. The detail of the expressive faces of the couple sitting in front of the cabin enjoying themselves (fig. 81) is an obvious Wiener motif. All of these elements serve to reaffirm the idea that Wiener, like V. Stanić, the Yugoslavian naive painter, "fondly creates compositions of human events . . . fraught with a poetically simple understanding of happiness and suffering. Folkloristic stylization and humorous simplicity give his ingenious scenes a pleasant work."[81]

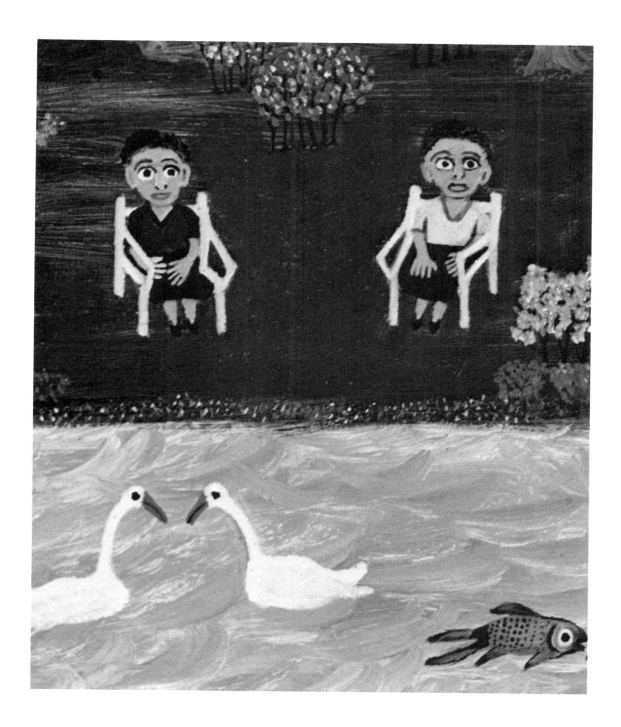

Figure 81. Detail of couple from *Lake Quassapaug* (fig. 79)

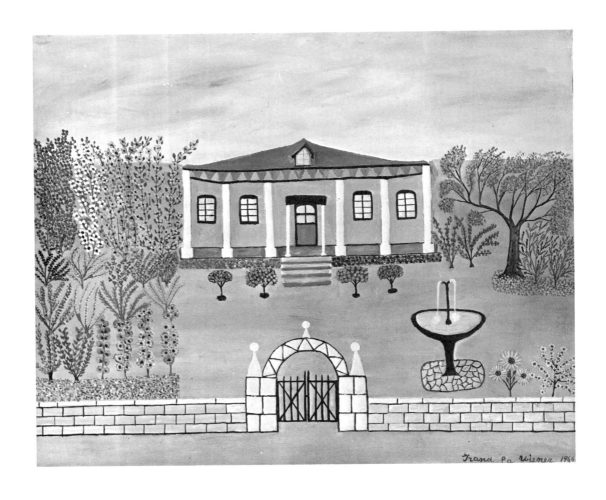

Figure 82. *The Gateway*. Courtesy of Mrs. Sandra Weiner. Photograph by New York State Historical Association.

The Gateway (fig. 82)

This work contains many familiar motifs used by Pop in other paintings—the gateway, the Greek Revival building, fountain, and floral patterns. They are objects which reminded the artist of happy times spent in the United States and show his keen awareness of the world around him. Pop's memory failed him, though his humor did not, when questioned about the subject of this painting. "Maybe it's the White House,"[82] he declared. Regardless of the subject matter, the painting shows the native mastery of his understanding of color. Like the naive painter Generalić, "in his works, colors become the mirror of his soul."[83] The soft subtle colors, like the turquoise background, the pink of the building repeated in the flowers, and the shades of green, produce a work which is most restful. In this picture Wiener achieved an excellent balance through color. The left side of the painting, for example, is more detailed, but is lighter in color. It balances with the right side which is heavier in color, but has less detail.

Shelter Island (fig. 83)

Pop definitely recalled the source of this delightful summer scene:

This here is a Shelter Island, Long Island . . . Danny had a cottage there and I used to go out fishing here at the end of the pier. Over here they used to have a boat house, years ago. . . . This is a pier, here [is] where they're bathing. I used to fish right here. Up here, there's a house where . . . there's a garden . . . a garden, a regular garden, an Italian garden. This is a pier house . . . there's flowers here, over here the kids used to play, a couple of cottages, one cottage there, Shelter Island . . . this I made, must be 1950 or '51.[84]

Sandra Weiner also remembered Pop had been to Shelter Island. "He spent some time with us there,"[85] she mentioned.

Certain aspects of this work merit greater attention than others. For example, the detail of the small house at the bottom right (fig. 85) illustrates Wiener's drawing skill. The columns, the roof, the gables facing opposite directions, the small door, are all very exactly executed, giving the cottage a toy house appearance.

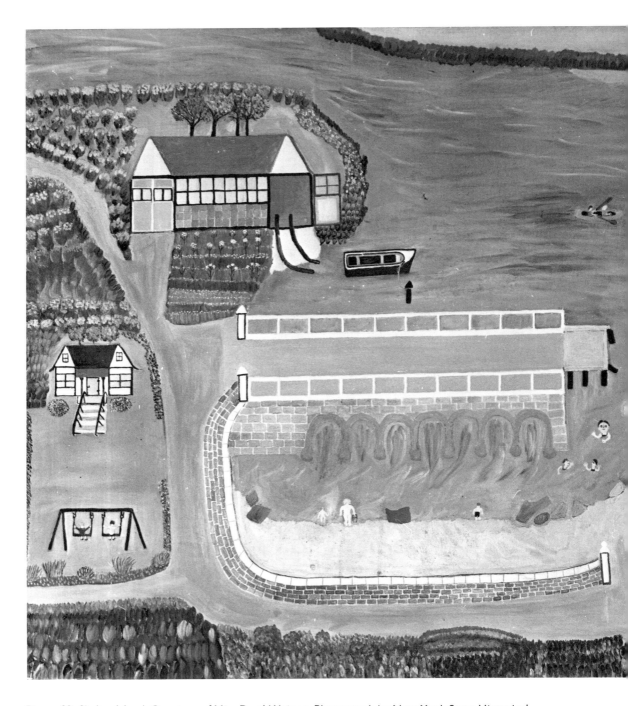

Figure 83. *Shelter Island*. Courtesy of Miss Doré Weiner. Photograph by New York State Historical Association.

Figure 84. Shelter Island, Long Island, 1969.
Courtesy of the Smithsonian Institution.

Figure 85. Detail of small house from *Shelter Island*
(fig. 83)

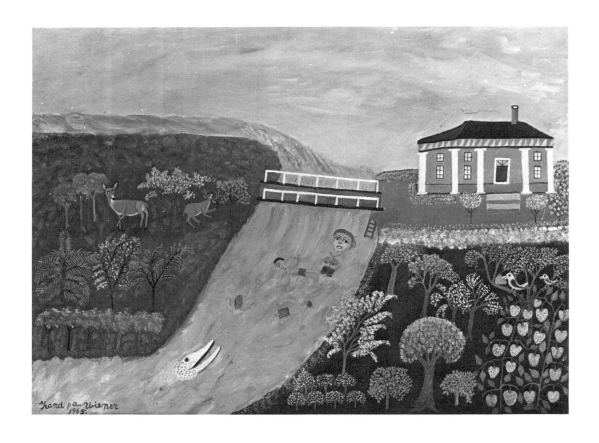

Figure 86. *Fun and Frolic*. Reproduced through courtesy of the New York State Historical Association.

Fun and Frolic (fig. 86)

This is a work which is as varied in its inspiration as it is in decorative patterning. Pop explained that the children playing with the fish in the painting were those he saw on the television show "Flipper"[86] playing with a dolphin. The Greek Revival building was used several times in Wiener's works and was inspired by a building he saw in America. The deer in the upper left-hand corner, on the other hand, is an important character in Rumanian folk tales, often symbolizing a prince who has had a spell cast on him.[87] Then, too, the detail of the beautifully patterned floral bud and fruit arrangement (fig. 87) looks very much like the design work on a Rumanian carpet. In fact, when questioned about the inspiration of this section, Pop replied, "They used to have these here [pointing to his floral patterns], on the walls."[88] The viewer may sense a note of fear in the scared expression on the face of the child and the fierce appearance of the fish. Further questioning about the child's frightened look resulted in this characteristic answer from Pop: "She must be Jewish, she says oi!"[89]

This painting is a tribute to Wiener's sense of design and color. But more important, it reaffirms his vitality and love for all that is alive. Like André Bauchant, "his mountains, people and animals, all have a vegetable quality; all seem to be sprouting and growing."[90]

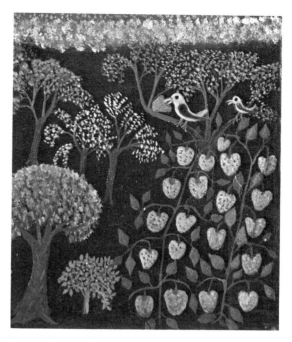

Figure 87. Detail of flower patterns from *Fun and Frolic* (fig. 86)

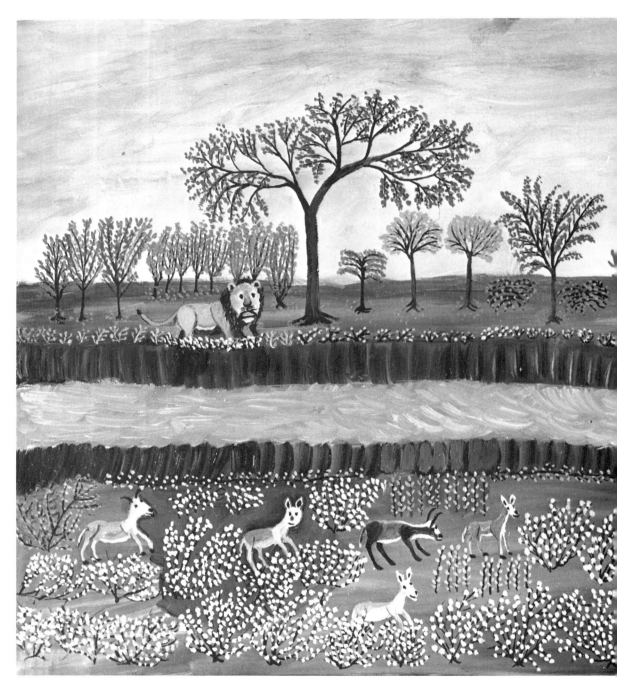

Figure 88. *Wild Animals*. Courtesy of Mrs. Sandra Weiner. Photograph by New York State Historical Association.

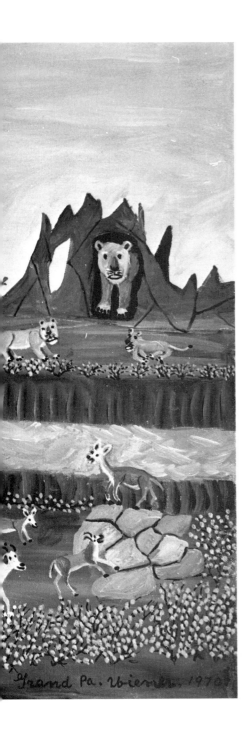

Wild Animals (fig. 88)

This is one of the last pictures Pop Wiener painted before his death in the fall of 1970. Its source may well be a memory of the interior of the Bronx Zoo or the Museum of Natural History. A personal interpretation, however, would place its significance far beyond this. The intricately patterned trees and animals, remarkably designed from any point of view, bid farewell to the artist who will soon travel along the river of eternity.[91] There is a sense of intimacy with nature permeating the painting which brings to mind the artist's early acquaintance with the Rumanian philosophy of *Miorița*. It is as if Pop's animal friends agree to form an honor guard which welcomes his entrance into the perpetual enjoyment of nature and beauty. Even the colors in the painting—greys, blues, subtle orange, tan—are symbolic of tranquility, and the peace and rest which await him. The long horizontal, dissecting the work in two, likewise contributes to the atmosphere of peaceful repose, making this painting a culminating tribute to all Pop Wiener loved and painted.

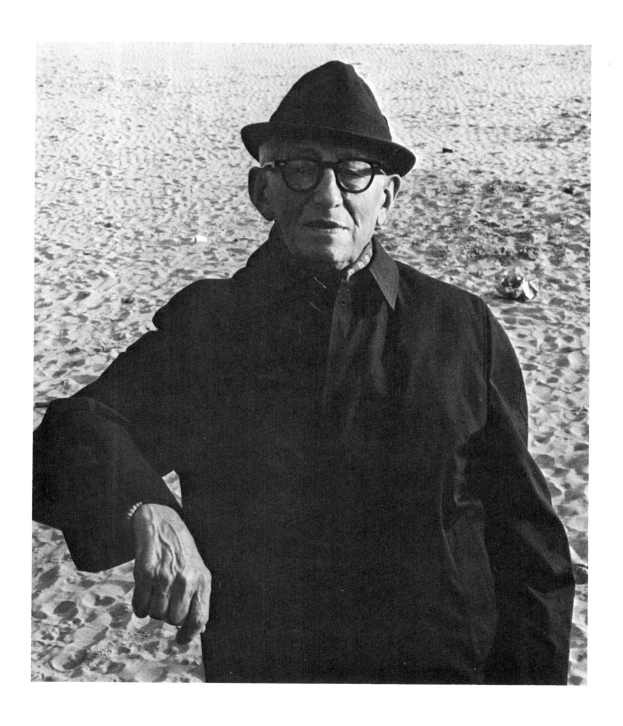

Figure 89. Pop Wiener, shortly before his death in 1970. Photograph by Sandra Weiner.

5

Conclusion

Isidor Wiener started painting late in life in a very personal way and for purely subjective reasons. The fruits of his labors were a large body of naive paintings whose significance far exceeds the irony of the circumstances which surrounded his path to artistic recognition. In producing naive art, Wiener, like other contemporary naive painters, answers the strong need of the American artistic conscience for a kind of painting which is aesthetically provocative while remaining intelligible, fresh and direct without being fatuous, and culturally valuable yet artistically appealing.

Pop Wiener provides the viewer with insights into the cultural history of the Russian Jew who emigrated from Russia to the United States in the early nineteenth century. His work displays a distinct American-Jewish spirit while at the same time demonstrates an association with an American naive painting tradition. Wiener accomplished this by a unique combination of sources. He integrated and synthesized, for example, the media—television, movies, advertisements, periodicals, and magazines—with memories, and the symbols of those recollections, of his east European heritage.

In all of this Wiener revealed that his work and life were inseparable. While other artists keep the two apart, the naive artist, because his work is so personal, cannot do so. In fact his painting is not likely to be appreciated without an awareness of his background.

What began for Isidor Wiener as an obvious subjective endeavor has resulted in paintings which have a universal appeal. Pop Wiener stripped his work of all superfluities, sharing with the viewer those basic emotions experienced in the joys and sorrows of life. In doing this he has created naive paintings which are not only relevant, but may some day be called masterly.

Appendix I

Title	Signed	Year	Medium	Size (in inches)	Collection
Adam and Eve	Wiener Grandpa is overpainted	1965	oil on canvas	20 × 16	Bradley Smith, New York, N.Y.
Noah's Ark	Grand pa Wiener Noah's Ark	1967	oil on canvas	24 × 30	New York State Historical Assoc.
Moses and the Ten Commandments	Grand Pa. Wiener	1965	oil on canvas	20 × 16	Mr. and Mrs. Samuel Weiner, Smallwood, N.Y.
Daniel in the Lions' Den	Grand pa Wiener	1963	oil on canvas	16 × 20	Mrs. Sandra Weiner, New York, N.Y.
Crossing the Red Sea	Grand.Pa.Wiener.	1967	oil on canvas	24 × 30	New York State Historical Assoc.
Child Lost in the Woods	Grand Pa. Wiener.	1965	oil on canvas	20 × 16	James O. Keene, Burmingham, Mich.
Three Birds in Springtime	Grand Pa Wiener	1969	oil on canvas	16 × 20	Mrs. Sandra Weiner, New York, N.Y.
Village Scene	no signature	no date: about 1951	oil on canvas	$17\frac{3}{4}$ × 24	Mrs. Sandra Weiner, New York, N.Y.
Four Birds in a Garden	Grand. pa Wienenr.	no date	oil on canvas	$11\frac{1}{2}$ × $15\frac{1}{2}$	Mrs. Sandra Weiner, New York, N.Y.
Church in the Valley	no signature	no date	oil on canvas	$23\frac{1}{2}$ × $29\frac{1}{2}$	Mrs. Sandra Weiner, New York, N.Y.
Mountain Scene	Grand pa Wiener.	1962	oil on canvas	20 × 24	Mrs. Sandra Weiner, New York, N.Y.
Four Cows and a Bull	no signature	no date	oil on canvas	16 × $21\frac{1}{2}$	Mrs. Sandra Weiner, New York, N.Y.
Pastoral Scene	no signature	no date	watercolor (under glass)	$9\frac{3}{4}$ × $13\frac{3}{4}$	Mrs. Sandra Weiner, New York, N.Y.
Horse and Cart	no signature	no date	oil on canvas	$17\frac{1}{2}$ × $25\frac{3}{4}$	Mrs. Sandra Weiner, New York, N.Y.

Title	Signed	Year	Medium	Size (in inches)	Collection
The Witch in the Woods	GrandPa. Wiener	1966	oil on canvas	20×16	New York State Historical Assoc.
Orange Bowl of Flowers	Grand Pa Wiener	1966	oil on canvas	20×16	Mrs. Sandra Weiner, New York, N.Y.
Harvesting	Grand Pa. Wiener	1963	oil on canvas	16×20	Mrs. Judith Stanton, New York, N.Y.
Odessan Still Life	I. Wiener	no date	oil on canvas	$12 \times 15\frac{3}{4}$	Mrs. Sandra Weiner, New York, N.Y.
The Falcon	Grand Pa. Wiener	1965	oil on canvas	16×12	New York State Historical Assoc.
Rawhide	Grand Pa Wiener	1966	oil on canvas	20×24	Mrs. Sandra Weiner, New York, N.Y.
Ginger	no signature	no date	oil on canvas	16×20	Mrs. Sandra Weiner, New York, N.Y.
Eggplant Tree	I. Wiener	1958	oil on canvas	$23\frac{1}{2} \times 15\frac{1}{2}$	Mrs. Sandra Weiner, New York, N.Y.
Bar Scene	I. Wiener	1960	oil on canvas	20×24	Mrs. Sandra Weiner, New York, N.Y.
John Fitzgerald Kennedy	Grand Pa. Wiener President John F. Kennedy	no date: about 1963	oil on canvas	16×20	Mrs. Sandra Weiner, New York, N.Y.
Knickerbocker Village	Pop Wiener	1967	oil on canvas	20×24	Mrs. Sandra Weiner, New York, N.Y.
Copy of Monet	Grand Pa. Wiener.	1968	oil on canvas	20×24	Mrs. Sandra Weiner, New York, N.Y.
The Bull	Grand Pa. Wiener	1965	oil on canvas	20×24	Mrs. Sandra Weiner, New York, N.Y.
Political Panorama	I. Wiener	1960	oil on canvas	16×20	Mrs. Sandra Weiner, New York, N.Y.
Greek Revival in Hartford	Grand Pa Wiener	1962	oil on canvas	18×14	Mrs. Sandra Weiner, New York, N.Y.
The Circus	Grand Pa. Wiener	1962	oil on canvas	20×16	Mrs. Sandra Weiner, New York, N.Y.
Bathing and Boating Scene	Grand pa Wiener	1968	oil on canvas	16×20	Mrs. Sandra Weiner, New York, N.Y.
Jungle Scene	Grand Pa. Wiener.	1966	oil on canvas	$17 \times 21\frac{1}{2}$	Samuel Weiner, Smallwood, N.Y.
The Jungle	Grand Pa Wiener	1964	oil on canvas	24×36	Bradley Smith, New York, N.Y.
Korean War Scene I	Grand Pa Wiener	1967	oil on canvas	20×24	Mrs. Sandra Weiner, New York, N.Y.
Man in Boat	Grand Pa. Wiener.	1966	oil on canvas	20×24	Mrs. Sandra Weiner, New York, N.Y.

Title	Signed	Year	Medium	Size (in inches)	Collection
Two Cars Climbing a Hill	I. Wiener	1959	oil on canvas	18 × 24	Mrs. Sandra Weiner, New York, N.Y.
Street Scene	GrandPa Wiener	1962	oil on canvas	20 × 24	Mrs. Sandra Weiner, New York, N.Y.
Lake Quassapaug	Grand Pa Wiener	1964	oil on canvas	16 × 20	Mrs. Sandra Weiner, New York, N.Y.
The Gateway	Grand Pa Wiener	1966	oil on canvas	20 × 24	Mrs. Sandra Weiner, New York, N.Y.
Shelter Island	no signature	no date	oil on canvas	24 × 30	Miss Doré Weiner, New York, N.Y.
Fun and Frolic	Grand pa. Wiener	1965	oil on canvas	18 × 24	New York State Historical Assoc.
Wild Animals	Grand Pa. Wiener	1970	oil on canvas	18 × 24	Mrs. Sandra Weiner, New York, N.Y.
Early Water Color A	no signature	no date	watercolor (under glass)	$9\frac{3}{4} \times 13\frac{3}{4}$	Mrs. Sandra Weiner, New York, N.Y.
Early Water Color B	no signature	no date	watercolor on paper	$13\frac{3}{4} \times 16\frac{1}{2}$	Mrs. Sandra Weiner, New York, N.Y.
Housetops	no signature	1957	oil on canvas	20 × 16	Robert Allen Aurthur, Amagansett, Long Island
The Lion	no signature	no date	plastic wood		New York State Historical Assoc.
Sculptured Birds	no signature	no date	plastic wood		Mrs. Sandra Weiner, New York, N.Y.

Appendix 2

Foreword to "Grand Pa Wiener: A Loan Exhibition of Works by a Twentieth Century Folk Artist," the catalog of Pop Wiener's one-man show at the New York State Historical Association, Cooperstown, New York, July–November 1970.

Foreword

In recent years this Association has been slowly adding the work of a few 20th century naive artists to its notable collection of American Folk Art. Works by J. O. J. Frost, Grandma Moses, John Scholl, Frank Moran, Frank Sweet and Will Edmondson have brightened the collection and brought the folk tradition down to our times.

The work of Isidor Wiener combines many elements familiar to the student of naive art. It is often nostalgic, going back to his boyhood for its sources, like the work of Grandma Moses and Aunt Clara Williamson. It calls to mind Hicks with its strong emphasis on biblical scenes and its fascination with birds and animals. Just as hundreds of naive painters in the 19th century relied upon prints, engravings and wood cuts for their inspiration, so *Life* magazine, television and other mass media triggered paintings for Mr. Wiener.

While one can find many qualities of Wiener's work in common with other naive artists in both America and Europe, he has a special distinction in that here is the artistic and emotional record of one of those millions who came out of Central Europe with its long-established folkways, and started over at the age of 17 in the United States. The memories of the Old World and the impact of the New are juxtaposed but always the view of life is optimistic.

The flowers are blooming in neat rows, the colors are gay. The viewer smiles with the artist.

The exhibition falls into six themes. The first reflects his interest in birds and animals, an interest reflected also in the second group, which retells stories from the Old Testament of Adam and Eve, Noah's Ark and Moses. There is a group of still lifes, followed by remembered scenes from Rumanian Russia, then impressions of the new land. Of the latter, some are city scenes but many reflect the world around Monticello, N.Y., where he has spent a large part of his painting years. Finally, there are some examples of the impact of news media upon the artist. Although he frequently repeats a subject, the treatment is always varied, as will be seen in the paintings shown here.

Two women have made this show possible: Sandra Weiner (Mrs. Daniel Weiner) has encouraged her father-in-law over the years in every way possible to continue his painting. Without her total cooperation from the beginning of the venture, we could not have proceeded or succeeded.

Joanne Bock was a student in the Cooperstown Graduate Programs in 1968–69 and did her Master's thesis on Pop Wiener (Everyone calls him "Pop" but he usually signs his paintings "Grand Pa"; he spells his name Wiener, other members of the family spell it Weiner) and his work. Her many hours of tape-recorded conversations about his life and art are a remarkable record of how the naive artist feels about his work and how the immigrant looks back on his pioneering days in the new country. Her thesis is the rock on which the exhibit is based. In conclusion, may I thank each of the lenders, but especially Sandra Weiner and her daughter, Doré,

and salute my colleague, C. R. Jones, Associate Curator, for developing the exhibition and the catalogue.

Louis C. Jones
Director

Excerpts from the catalog of the Bianchini Gallery, 16 East 78th Street, New York, produced for its exhibition "Primitive Paintings Today," March 26 through April 20, 1963.

Jury-selected Primitive Paintings by Living Americans form Large, Lively Exhibition at Bianchini Gallery

Forty-nine paintings by 26 primitive, self-taught artists, many of them Senior Citizens, have been selected by jury from 160 entries submitted from all over the country, to be shown at the Bianchini Gallery, 16 East 78 Street, from March 26 through April 20. The competitive exhibition, which was open without fee to all living American primitive painters, was juried by Mrs. Adele Earnest, a Trustee of the Early American Folk Arts Museum of New York, and Mrs. Hertha Wegener, until recently Associate Curator of Painting and Sculpture at The Brooklyn Museum. These experts generously assisted the gallery's director in the selections for the show. . . .

.

Among the numerous . . . entries selected, three small paintings by I. Wiener, an octogenarian of New York City, are full of humor—"City Man with a Bull," "Daniel in the Lion's Den" and a lush and brilliant garden in which Eve communes with the serpent while Adam hides behind a tree on the other side of the picture.

Notes

All information in chapters two, three, and four not specifically annotated is taken from the taped interviews listed in the bibliography. Copies of a complete list of their contents, compiled by the author, may be obtained on request from the publisher.

1. Introduction

1. Oto Bihalji-Merin, *Modern Primitives*, p. 66.
2. See Bihalji-Merin, *Masters of Naive Art* and Robert Goldwater, *Primitivism in Modern Art* for detailed discussion of these terms.
3. Sidney Janis, *They Taught Themselves*, p. 7.
4. Ibid., p. 10.
5. Ibid.
6. Donald and Margaret Vogel, *Aunt Clara*, p. 1.
7. By Holger Cahill et al.

2. "Pop" the Man

1. Mrs. Sunna Rasch, taped interview with author, Feb. 7, 1969.
2. Pop Wiener, taped interview with author, Feb. 7, 1969.
3. Pop Wiener, interview with author, July 18, 1969.
4. Taped interview, Feb. 7, 1969.
5. Ibid.
6. Taped interview, May 2, 1969.
7. Taped interview, Feb. 7, 1969.
8. Ibid.
9. Ibid.
10. Taped interview, May 2, 1969.
11. Taped interview, Feb. 7, 1969.
12. Ibid.
13. Ibid.
14. Ibid.
15. Ibid.
16. Taped interview, Feb. 23, 1969.
17. Pop Wiener, taped interview, Feb. 7, 1969.
18. Ibid.
19. Ibid.
20. Ibid.
21. Ibid.
22. Ibid.
23. Ibid.
24. Ibid.
25. Ibid.
26. Ibid.
27. Ibid.
28. Taped interview, Feb. 23, 1969. Sandra and Samuel Weiner spell their last name *ei* instead of *ie*, which Pop used.
29. Pop Wiener, taped interview, Feb. 7, 1969.
30. Ibid.
31. Ibid.
32. Ibid.
33. Ibid.
34. Taped interview, Feb. 23, 1969.
35. Taped interview, Feb. 7, 1969.
36. Taped interview, Feb. 23, 1969.
37. Letter from Samuel Weiner to author, Dec. 20, 1972.
38. Taped interview, Feb. 7, 1969.
39. Ibid.
40. Taped interview, Feb. 23, 1969.
41. Taped interview, July 12, 1969.
42. Ibid.
43. Taped interview, July 6, 1969.
44. Ibid.
45. Taped interview, Feb. 7, 1969.
46. Taped interview, Feb. 23, 1969.
47. Ibid.

3. "I Saw It, I Like It, I Painted It"

1. Oto Bihalji-Merin, *Modern Primitives*, p. 34.
2. Taped interview with author, Feb. 23, 1969.
3. Arsen Pohribný and Štefan Tkáč, *Naive Painters of Czechoslovakia*, p. 27.
4. Taped interview, Feb. 7, 1969.
5. Pohribný and Tkáč, *Naive Painters*, p. 29.
6. Taped interview, May 2, 1969.
7. Taped interview, Feb. 7, 1969.
8. Ibid.
9. Sandra Weiner, interview with author, Aug. 11, 1969.
10. Letter from Samuel Weiner to author, Aug. 8, 1969.
11. Taped interview, Feb. 7, 1969.
12. Ibid.
13. Ibid.
14. Ibid.
15. Ibid.
16. Ibid.
17. Ibid.
18. Oto Bihalji-Merin, *Primitive Artists of Yugoslavia*, p. 25.
19. Mrs. Sunna Rasch, taped interview, Feb. 7, 1969.
20. Taped interview, May 2, 1969.
21. Taped interview, Feb. 7, 1969.
22. Ibid.
23. Ibid.
24. See Appendix 2.
25. See Appendix 2.
26. Taped interview, Feb. 7, 1969.
27. Bihalji-Merin, *Primitive Artists*, p. 25.
28. Taped interview, Apr. 3, 1969.
29. Group discussion with Dr. Alfred Frankenstein at Cooperstown Graduate Program, Feb. 15, 1969.
30. Robert Goldwater, *Primitivism in Modern Art*, p. 189.
31. Taped interview, Apr. 21, 1969.

32. Donald and Margaret Vogel, *Aunt Clara*, p. 1.

33. Taped interview, May 2, 1969.

34. Pohribný and Tkáč, *Naive Painters*, p. 30.

35. Taped interview, Feb. 7, 1969.

36. Taped interview, Feb. 23, 1969.

37. Vogel, *Aunt Clara*, p. 2.

38. Taped interview, Feb. 7, 1969.

39. Taped interview, Feb. 23, 1969.

40. Taped interview, May 2, 1969.

41. Sidney Janis, *They Taught Themselves*, p. 9.

42. Bihalji-Merin, *Modern Primitives*, p. 20.

43. Bihalji-Merin, *Primitive Artists*, p. 9.

44. Bihalji-Merin, *Modern Primitives*, p. 54.

45. Ibid., p. 96.

46. *Life*, Nov. 23, 1962, pp. 54–55.

47. Taped interview, Feb. 7, 1969.

48. Ibid.

49. Interview with Mircea Mitran, Sept. 28, 1972.

50. Taped interview, Feb. 7, 1969.

51. Ibid.

52. Taped interview, May 2, 1969.

53. See pp. 77, 79 for an excerpt from this ballad.

54. Franz Josef Auerbach, Dan Grigorescu, taped interview, Oct. 4, 1972.

55. *Roumanian Peasant Art*, pp. 1–2.

56. Ibid., p. 10.

57. H. J. Hansen, ed., *European Folk Art in Europe and the Americas*, p. 191.

58. *Roumanian Peasant Art*, p. 45.

59. Marcela Focşa, *Folk Art Museum of the Socialist Republic of Romania*, p. 18.

60. Shalom of Safed is a naive Jewish painter, now (1973) painting in Israel in the Orthodox Jewish tradition.

61. Daniel Doron, "The Innocent Eye of Shalom," *Jewish Heritage* (Fall 1969), p. 46.

62. See pp. 53–61 for Wiener's interpretation of Biblical scenes and Doron's "The Innocent Eye of Shalom" for Shalom's humorous stories.

4. "He Paints That Way Because He Is That Way"

1. Taped interview, Feb. 7, 1969.

2. Interview, Oct. 19, 1972.

3. Daniel Doron, taped interview, Sept. 17, 1972.

4. Oto Bihalji-Merin, *Modern Primitives*, p. 68.

5. Dan Grigorescu, taped interview, Oct. 4, 1972.

6. Jean Lipman, *American Folk Art in Wood, Metal and Stone*, p. 41.

7. Taped interview, May 2, 1969.

8. Taped interview, July 12, 1969.

9. Ibid.

10. Angelo S. Rappoport, *The Folklore of the Jews*, pp. 118–19.

11. Taped interview, May 2, 1969.

12. M. Gaster, *Rumanian Bird and Beast Stories*, pp. 2–3, and Dov Noy, *Folktales of Israel*, p. 59.

13. Taped interview, May 1, 1969.

14. Interview, Dec. 27, 1972.

15. Taped interview, May 2, 1969.

16. See p. 41 for an explanation of Mioritic space.

17. Dan Grigorescu, taped interview, Oct. 4, 1972.

18. Taped interview, May 2, 1969.

19. Bihalji-Merin, *Primitive Artists of Yugoslavia*, pp. 142–43.

20. Israil Bercovici, interview, Dec. 27, 1972.

21. Gaster, *Rumanian Stories*, p. 280.

22. Petru Comarnescu, *Ion Ţuculescu*, p. 55.

23. Taped interview, May 2, 1969.

24. Sister Justin McKiernan, taped interview, Apr. 8, 1969.

25. Bihalji-Merin, *Primitive Artists*, p. 130.

26. Israil Bercovici, interview, Dec. 27, 1972.

27. Arsen Pohribný and Štefan Tkáč, in *Naive Painters of Czechoslovakia*, pp. 26–27, make this comparison between primitive art in general and folk speech. I am applying these quotations specifically to Wiener's painting *Village Scene* (fig. 36).

28. Israil Bercovici, interview, Dec. 27, 1972.

29. Bihalji-Merin, *Primitive Artists*, p. 140.

30. Taped interview, May 2, 1969.

31. Israil Bercovici, interview, Dec. 27, 1972.

32. Bihalji-Merin, *Primitive Artists*, p. 130.

33. Ibid., p. 26.

34. Taped interview, May 2, 1969.

35. Ibid.

36. Bihalji-Merin, *Primitive Artists*, p. 105.

37. Lucian Blaga, "Old Romanian Ballad Translated by Famous American Poet," *Romanian Bulletin* (July 1972), p. 6.

38. Taped interview, Feb. 7, 1969.

39. Taped interview, May 2, 1969.

40. Israil Bercovici, interview, Dec. 27, 1972.

41. Ibid. According to Bercovici the witch is wearing a type of early Dacian shoe called *opinca*, which was made from pigskin and often laced up to the knee.

42. Mark Zborowoski and Elizabeth Herzog, *Life Is with People*, p. 91.

43. Dr. Mircea Bichiceanu and Rodica Rarău-Bichiceanu, *Flowers of Rumania*, pp. 23, 27.

44. This quotation comes from the film *Anotoimpur si Cuolri* [Seasons in Color], produced by C. Constantinescu.

45. Comarnescu, *Ion Ţuculescu*, p. 42.

46. Moses Rischin, *The Promised City*, p. 29.

47. Stith Thompson, *Motif Index of Folk Literature*, vol. I, p. B592.

48. Pop Wiener, taped interview, May 2, 1969.

49. Ibid.

50. Rappoport, *The Folklore of the Jews*, p. 37.

51. Bihalji-Merin, *Modern Primitives*, p. 62.

52. Taped interview, May 2, 1969.

53. Holger Cahill et al., *Masters of Popular Painting*, pp. 31–32.

54. See figure 54.

55. Taped interview, May 2, 1969.

56. Bihalji-Merin, *Modern Primitives*, p. 51.

57. Pop Wiener, taped interview, May 2, 1969.

58. Bihalji-Merin, *Primitive Artists*, p. 56.

59. Mrs. Sunna Rasch, taped interview, Feb. 7, 1969.

60. Taped interview, May 2, 1969.

61. Ibid.

62. Ibid.

63. Ibid.

64. Ibid.

65. Sidney Janis, *They Taught Themselves*, p. 20.

66. Bihalji-Merin, *Primitive Artists*, p. 107.

67. Franz Josef Auerbach, taped interview, Oct. 4, 1972.

68. Arsen Pohribny and Štefan Tkáč, *Naive Painters of Czechoslovakia*, p. 32.

69. Taped interview, May 2, 1969.

70. Ibid.

71. Ibid.

72. Ibid.

73. Janis, *They Taught Themselves*, p. 6.

74. Bihalji-Merin, *Modern Primitives*, p. 65.

75. Taped interview, July 12, 1969.

76. Taped interview, Feb. 7, 1969.

77. Comarnescu, *Ion Țuculescu*, p. 48.

78. Taped interview, July 12, 1969.

79. Taped interview, May 2, 1969.

80. Ibid.

81. Bihalji-Merin, *Primitive Artists*, pp. 144–45.

82. Taped interview, May 2, 1969.

83. Bihalji-Merin, *Primitive Artists*, p. 54.

84. Taped interview, May 2, 1969.

85. Taped interview, Feb. 23, 1969.

86. Mrs. Sandra Weiner, interview, July 6, 1969. Pop had mentioned that the source of this painting was a television show. He could not recall the name of it, but his granddaughter was able to supply me with this information when I interviewed her mother.

87. Dan Grigorescu, taped interview, Oct. 4, 1972.

88. Taped interview, May 2, 1969.

89. Ibid.

90. Bihalji-Merin, *Modern Primitives*, p. 66.

91. The interpretation of this painting does not exclude from consideration any Judaic beliefs Wiener may have held about death. He never mentioned his thoughts on this subject in all my interviews with him. It merely suggests that the artist's Rumanian background seems to have exerted, at least in this painting, a more pronounced influence on him toward the end of his life.

Bibliography

Books

American Sculpture. An exhibition organized to inaugurate The Sheldon Sculpture Garden at the University of Nebraska, Lincoln. Presented as its annual exhibition by The Nebraska Art Association, Sept. 11 through Nov. 15, 1970.

Ausubel, Nathan. *The Book of Jewish Knowledge*. New York: Crown Publishers, 1964.

———. *A Treasury Of Jewish Folklore*. New York: Crown Publishers, 1948.

Babel, Isaak. *Benya Krik, The Gangster and Other Stories*. Edited by Avrahm Yarmolinsky. New York: Schocken Brooks, 1948.

Baconsky, A. E. de. *Ion Țuculescu*. Bucharest: Editure Meridiane, 1972.

Banateavu, Tancredi; Focșa, Gheorghe; and Ionescu, Emilia. *Folk Costumes, Woven Textiles and Embroideries of Rumania*. State Publishing House for Literature and the Arts, 1958.

Basdevant, Denise. *Against Tide and Tempest: The Story of Rumania*. New York: Robert Speller and Sons, 1965.

Beza, Marcu. *Paganism in Roumanian Folklore*. New York: E. P. Dutton and Co., 1926.

Bichiceanu, Dr. Mircea, and Rarău-Bichiceanu, Rodica. *Flowers of Rumania*. Bucharest: Meridiane Publishing House, 1964.

Bihalji-Merin, Oto. *Masters of Naive Art: A History and Worldwide Survey*. New York: McGraw-Hill Book Co., 1972.

———. *Modern Primitives: Masters of Naive Painting*. New York: Harry N. Abrams, 1959.

———. *Primitive Artists of Yugoslavia*. New York: McGraw-Hill Book Co., 1964.

Black, Mary, and Lipman, Jean. *American Folk Painting*. New York: Clarkson N. Potter, 1966.

Bossert, Helmuth Theodor. *Peasant Art of Europe and Asia*. New York: Frederick A. Praezer, 1966.

Bouret, Jean. *Douanier Rousseau*. Greenwich, Conn.: Faucett Publications, 1963.

Cahill, Holger, ed. *American Folk Art, The Art of the Common Man in America 1750–1900*. New York: The Museum of Metropolitan Art, 1932.

Cahill, Holger; Gauthier, Maximilien; Cassou, Jean; Miller, Dorothy C. *Masters of Popular Painting: Modern Primitives of Europe and America*. Reprint. New York: Arno Press, for the Museum of Modern Art, 1966.

Comarnescu, Petru. *Ion Țuculescu*. Bucharest: Meridiane Publishing House, 1967.

Conrad, Jack Randolph. *The Horn and the Sword: The History of the Bull as Symbol of Power and Fertility*. New York: E. P. Dutton and Co., 1957.

Crespelle, Jean-Paul. *The Love, the Dreams, the Life of Chagall*. New York: Coward, McCann, 1969.

Craven, Wayne. *Sculpture in America*. New York: Thomas Y. Crowell Co., 1968.

Encyclopedia Judaica. Vol. 6, *Di-Fo.* New York: Macmillan Co., 1971.

Fairy Tales and Legends from Romania. Translated from the Romanian by loava Sturdza, Raymond Vianu, Mary Lazarescu. New York: J. Wayne, 1972.

Focşa, Gheorghe H. *The Village Museum: An Open Air Ethnographic Museum.* Bucharest: 1966.

————. *The Village Museum in Bucharest.* Bucharest: Meridiane Publishing House, 1967.

Focşa, Marcela. *Folk Art Museum of the Socialist Republic of Romania.* Bucharest: Meridiane Publishing House, 1967.

————. *Le Musée d'Art Populaire de la République Socialiste de Roumanie.* Bucharest: Meridiane Publishing House, 1967.

————. *Scoarţe Românesti din colectia Muzeulu de arta populara al R. S. Romania* [Rumanian carpets in the collection of the Museum of Folk Art, Socialist Republic of Romania]. Bucharest: 1970.

Garbish Collection, National Gallery of Art 1-2, 1954-1957. *American Primitive Paintings from the Collection of Edgar Williams and Bernice Chrysler Garbish.* Introduction by John Walker, Chief Curator. Washington, D.C.: National Gallery of Art, 1954.

Gardner, Albert Teneyck. *Yankee Stonecutters.* New York: Columbia University Press, 1945.

Gaster, M. *Rumanian Bird and Beast Stories.* London: Sedgwick and Jackson, 1915.

Gaster, Theodor Hugh. *The Holy and the Profane, The Evolution of Jewish Folkways.* New York: William Sloane Associates, 1955.

Ginzberg, Louis. *Legends of the Bible.* New York: Simon and Schuster, 1956.

Goldwater, Robert. *Primitivism in Modern Art.* New York: Vintage Books, 1968.

Hansen, H. J., ed. *European Folk Art in Europe and the Americas.* Introduction by Robert Wildhaber. New York: McGraw-Hill Book Co., 1968.

Hapgood, Hutchins. *The Spirit of the Ghetto: Studies of the Jewish Quarter of New York.* New York: Shocker Brooks, 1966.

Ickis, Marguerite. *Folk Arts and Crafts.* New York: Association Press, 1958.

Irimie, Cornel, and Focşa, Marcela. *Icoane Pe Sticlă* [Icons on glass]. Editura Meridiane, 1971.

————. *Romanian Icons Painted on Glass.* Bucharest: Meridiane Publishing House, 1969.

An Isaac Bashevis Singer Reader. New York: Farrar, Straus and Giroux, 1971.

Jelavich, Charles, and Jelavich, Barbara. *The Balkans.* Englewood Cliffs: Prentice-Hall, Inc., 1965.

Janis, Sidney. *They Taught Themselves: American Primitive Painters of the 20th Century.* New York: Dial Press, 1942.

Jones, Agnes Halsey. *Rediscovered Painters of Upstate New York.* Utica: Winchester Printing for Munson-Williams-Proctor Institute, 1958.

Kallir, Otto, ed. *Grandma Moses, My Life's History.* New York: Harper and Brothers, 1948.

Lambert, Margaret, and Marx, Enid. *English Popular Art.* New York: B. T. Batsford, 1951.

Lendvai, Paul. *Eagles in Cobwebs: Nationalism and Communism in the Balkans.* Garden City: Doubleday and Co., 1969.

Lipman, Jean. *American Folk Art in Wood, Metal and Stone.* New York: Dover Publications, 1972.

Nolan, Richard. *Margaret and Walter Keane.* Tomorrow's Masters Series, Portfolio Edition. San Francisco: Johnson Meyers, n.d.

Noy, Dov. *Folktales of Israel.* Chicago: University of Chicago Press, 1963.

Oprescu, Gheorghe. *Arta Tărănescă La Romăni* [Peasant art of Rumania]. Lucrare Insolitade Cincizeci si Opt Tabele De Ilustrate, 1922.

————. *L'Art du paysan Roumain.* Bucharest: Academia Romana, 1937.

Pohribný, Arsen, and Tkáč, Štefan. *Naive Painters of Czechoslovakia*. Prague: Svoboda, 1967.

Primitifs d'aujourd'hui Galerie Saint Honoré. Paris: 76 Faubourg Saint-Honoré, 1964.

Rappoport, Angelo S. *The Folklore of the Jews*. London: Soncino Press, 1937.

Ravage, M. E. *An American in the Making*. New York: Dover Publications, 1971.

Rischin, Moses. *The Promised City: New York's Jews 1870–1914*. New York: Harper and Row, 1962.

Romanian Poems: A Bilingual Anthology of Romanian Poetry. Cluj, Rumania: Dacia Publishing House, 1972.

Roth, Cecil, ed. *Jewish Art: An Illustrated History*. New York: McGraw-Hill Book Co., 1961.

Roumanian Peasant Art. Roumanian Pavilion, New York World's Fair Commission, 1940.

Schwarzbaum, Haim. *Studies in Jewish Folklore*. Berlin: Walter DeGruyter and Co., 1968.

Seitz, William. *Claude Monet*. The Library of Great Painters. New York: Henry N. Abrams, 1960.

Sokolov, Academician Y. *Russian Folklore*. Hatboro, Penn.: Folklore Associates, 1966.

Stein, Joseph. *Fiddler on the Roof*. New York: Crown Publishers, 1964. (Based on Sholom Aleichem's stories.)

Sweeney, James Johnson. *Marc Chagall*. In collaboration with The Art Institute of Chicago, The Museum of Modern Art, New York. Reprint. New York: Arno Press, for the Museum of Modern Art, 1969.

Taylor, Joshua. *Learning to Look: A Handbook for the Visual Arts*. Chicago: University of Chicago Press, 1957.

Thompson, Stith. *Motif Index of Folk Literature*. Vol. 1, A–C. Bloomington: Indiana University Press, 1955.

Tilea, Illeana. *Roumanian Peasant Literature*. London: Frederick Muller, 1946.

Vacaresco, Helene, ed., trans. *Songs of the Valian Voivode and Other Strange Folklore*. New York: Charles Scribner's Sons, 1905.

Vogel, Donald, and Vogel, Margaret. *Aunt Clara: The Paintings of Clara McDonald Williamson*. Austin: University of Texas Press, 1966.

Vydra, Josef. *Folk Painting on Glass*. London: Spring Books, n.d.

Welsh, Peter C. *American Folk Art: The Art and Spirit of a People, from the Eleanor and Mabel Van Olstyne Collection*. Washington, D.C.: Smithsonian Institution, 1965.

Yaffe, James. *The American Jews*. New York: Random House, 1968.

Zborowski, Mark, and Herzog, Elizabeth. *Life is With People*. New York: International Universities Press, 1953.

Articles and Essays

Berindei, Aga, trans. "Roumanian Folk Tales," and "The Twelve Princesses with the Worn-out Slippers." *Folklore: A Quarterly Review of Myth, Tradition, Institution and Custom* 26:296–329, 389–400. London: Sidgwick and Jackson, 1915.

Blaga, Lucian. "Old Romanian Ballad Translated by Famous American Poet," *Romanian Bulletin*, July 1972, pp. 5–6.

Doron, Daniel. "The Innocent Eye of Shalom." *Jewish Heritage*, Fall 1969, pp. 45–52.

Goldstein, Kenneth. "William Robbie: The Folk Artist of the Buchan District, Aberdeenshire." *Folklore in Action, Essays for Discussion in Honor of MacEdward Leach*. Ed. Horace Palmer Beck. Philadelphia: The American Folklore Society, 1962, pp. 101–11.

Taped Interviews

The tapes, as numbered below, are in the Archive of New York State Folklife Studies, New York State Historical Association, Cooperstown, New York.

69-0190 Pop Wiener (and Joanne Bock), Feb. 7, 1969.

69-0191 Pop Wiener (continuation); Mrs. Sunna Rasch, Feb. 7, 1969.

69-0192 Mrs. Sunna Rasch (cont.); Mrs. Sandra Weiner, Feb. 23, 1969.

69-0193 Mrs. Sandra Weiner (cont.); Jerry Cooke, Apr. 2; Mrs. Judith Stanton, Apr. 3, 1969.

69-0194 Mrs. Judith Stanton (cont.); Sister Justin McKiernan, Apr. 8, 1969; Pop Wiener, May 1, 1969.

69-0195 Pop Wiener (cont.), May 2, 1969.

69-0196 Pop Wiener, May 2 and July 12, 1969; Mrs. Sandra Weiner, July 6, 1969; Samuel Weiner, July 12, 1969.

73-0059 Daniel Doron, Sept. 17, 1972.

73-0060 Franz Josef Auerbach, Mircea Ciobanu (translator), Dan Grigorescu, Oct. 4, 1972.

73-0061 Dan Grigorescu (cont.).

73-0062 Dan Grigorescu (cont.); Morris Gertz, Oct. 19, 1972.

73-0069 Morris Gertz (cont.).

73-0075 Marek Web, Jan. 12, 1973.

Interviews

Interview with Pop Wiener, July 18, 1969.

Interview with Mrs. Sandra Weiner, July 6, 1969.

Interview with Mrs. Sandra Weiner (telephone), Aug. 11, 1969.

Interview with Mircea Mitran, Sept. 28, 1972.

Interview with Morris Gertz, Oct. 19, 1972.

Correspondence

Letter from Julian Schwartz, March 1973.

Letter from Samuel Weiner, Aug. 8, 1969.

Letter from Samuel Weiner, Dec. 20, 1972.

Group Discussion

Group discussion with Dr. Alfred Frankenstein at the Cooperstown Graduate Program, Feb. 15, 1969.

Films

Anotoimpur si Culori [Seasons in Color], from paintings by Ion Niţă Nicodin-Nita of Brustuti, produced by C. Constantinescu.

Shalom of Safed, produced by Daniel Doron.

Index